THE OFFICIAL
Sweet Home
COLORING BOOK

Carnby Kim & Youngchan Hwang

Walter Foster

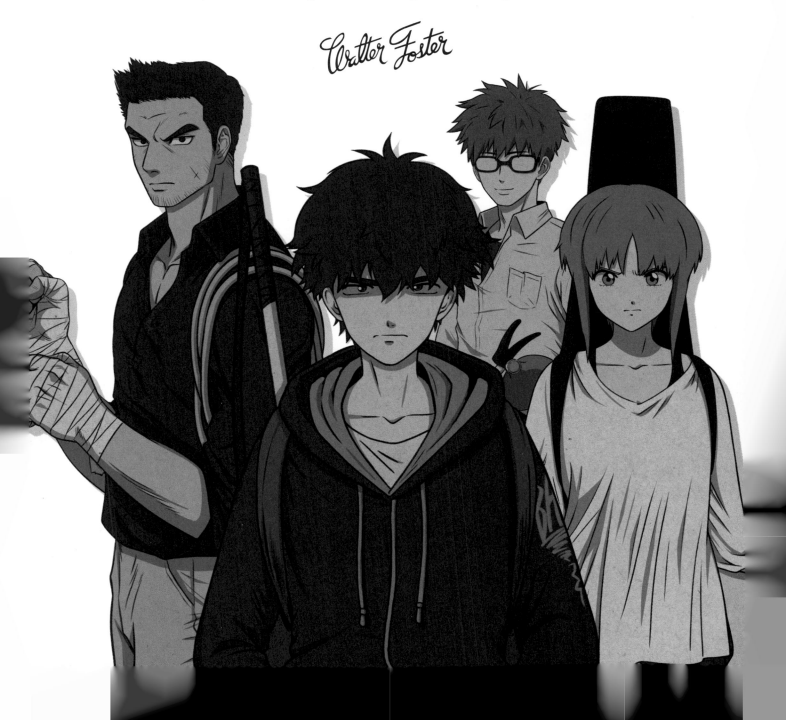

INTRODUCTION

Humans around the world have succumbed to the incomprehensible fate of monsterization. Will the residents of the Green Home apartment building survive, or are they destined to meet the same fate?

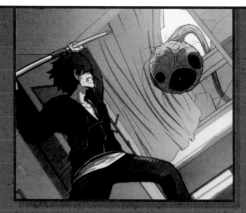
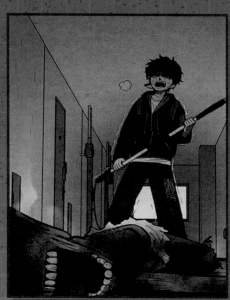
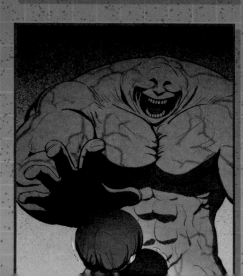
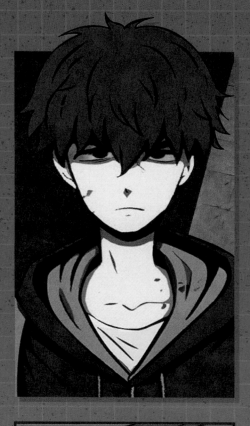
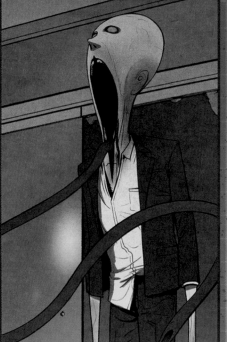
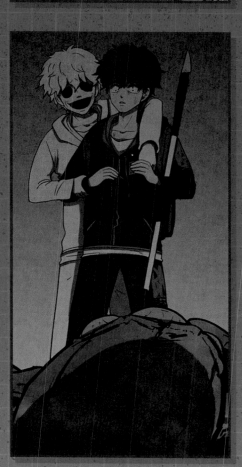
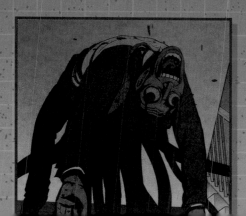

What Is Sweet Home?

In this webcomic thriller by Carnby Kim and illustrator Youngchan Hwang, Sweet Home follows the story Hyun Cha, a reclusive high school student forced to leave his home after an unexpected family tragedy—only to face something much scarier: a reality where monsters are trying to wipe out humanity. Now Hyun must fight alongside a handful of reluctant heroes to try and save the world before it's too late.

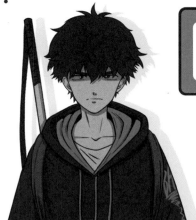

Check out the latest episode of the hit WEBTOON series.

SYNOPSIS

A reclusive loner, Hyun Cha is left alone after losing his parents and sister in a tragic accident. After selling his remaining property and moving into apartment 1410 in the Green Home building, Hyun decides to take his own life and sets a date for himself. As he goes about his uninspired day, he notices that his neighbor has stolen the ramen he was supposed to receive via home delivery. When he goes to investigate, he sees the woman next door has turned into a monster. Although he manages to avoid an immediate encounter with the monster, he sees it react to the sound of Jisoo Yoon's guitar music upstairs.

Hyun leaves his apartment and runs into a mysterious man name Wook. Soon thereafter, he collapses with a bloody nose. When Hyun wakes up the next day, he thinks he has had a vivid dream, but when he logs on to his computer, he finds a world ravaged by "monsterization." The residents of Green Home naturally congregate on the first floor near the security office and find themselves isolated, with the entrance to the building shuttered and the phone out of service. Now reduced to a group of survivors, can these residents survive the monsters inside and outside the building? And after Hyun's collapse and nosebleed, is he already on his way to being monsterized?

About WEBTOON

WEBTOON is the world's largest digital comics platform, home to some of the biggest artists, IP, and fandoms in comics. As the global leader and pioneer of the mobile webcomic format, WEBTOON has revolutionized the comics industry for comic fans and creators. Today, a diverse new generation of international comic artists have found a home on WEBTOON, where the company's storytelling technology allows anyone to become a creator and build a global audience for their stories. The WEBTOON app is free to download on Android and iOS devices.

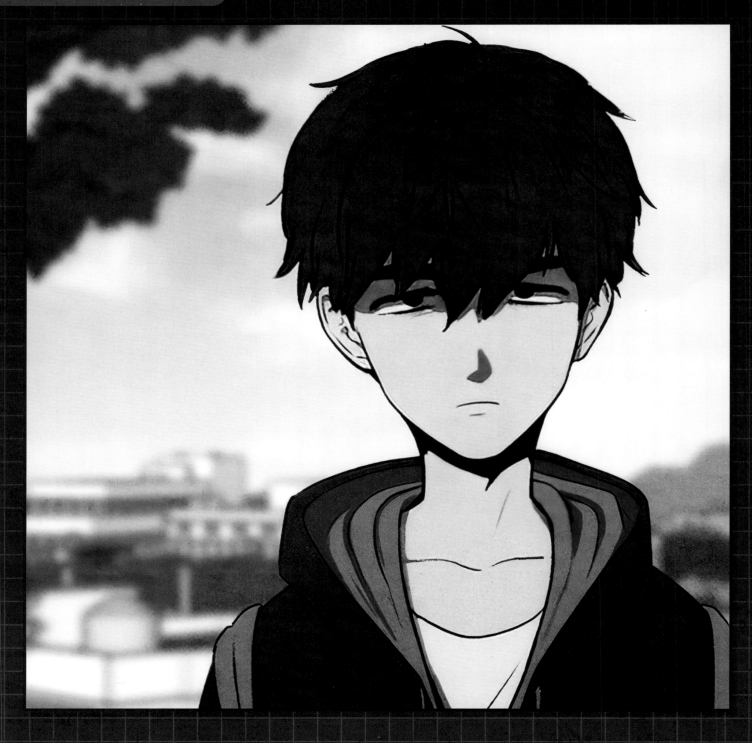

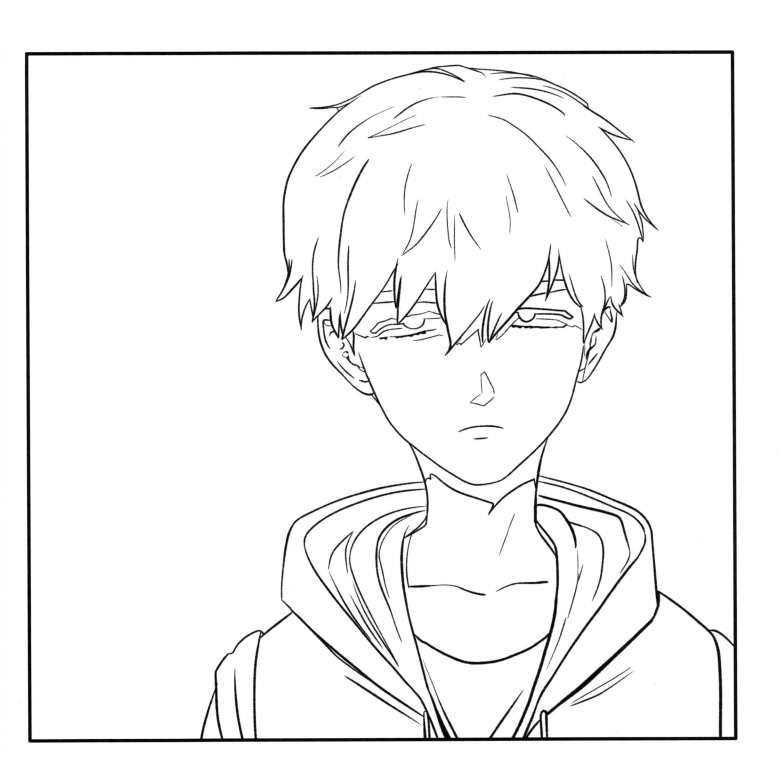

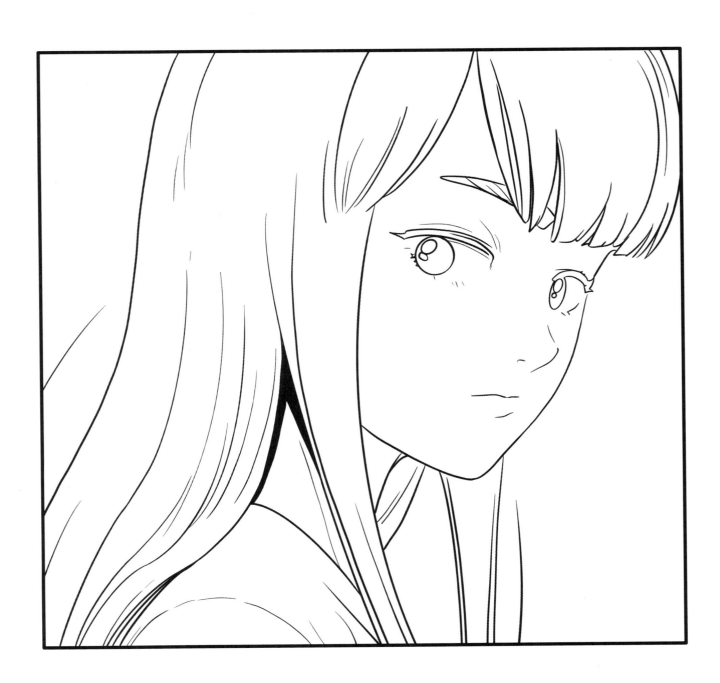

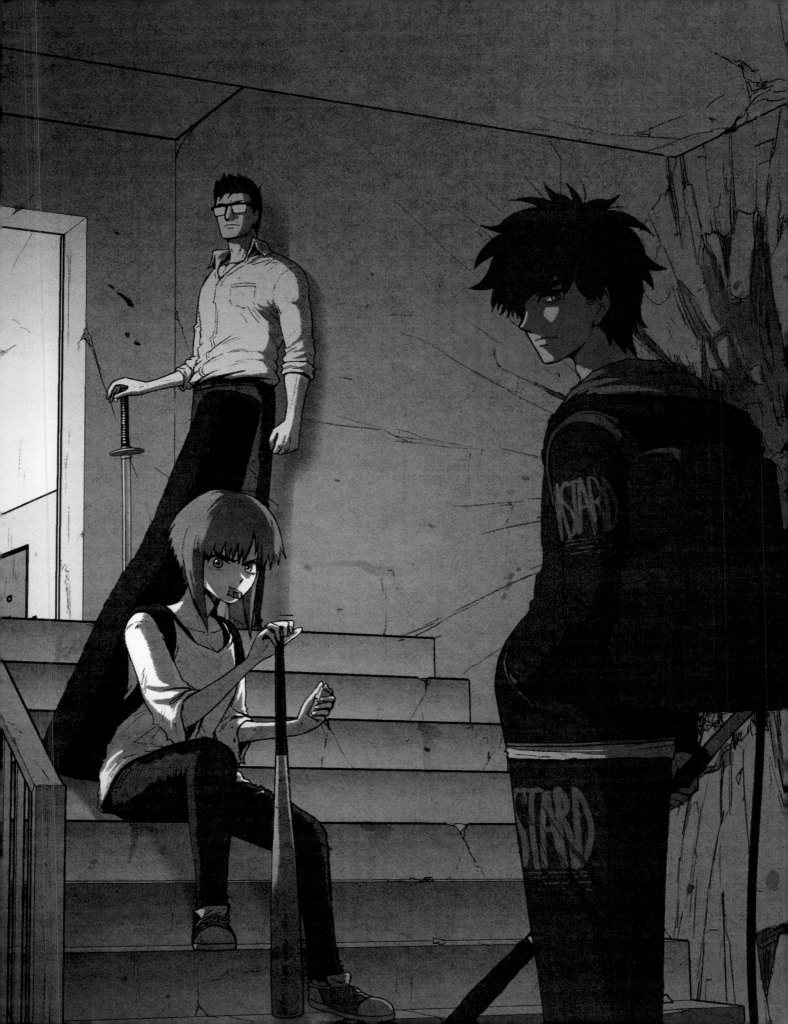

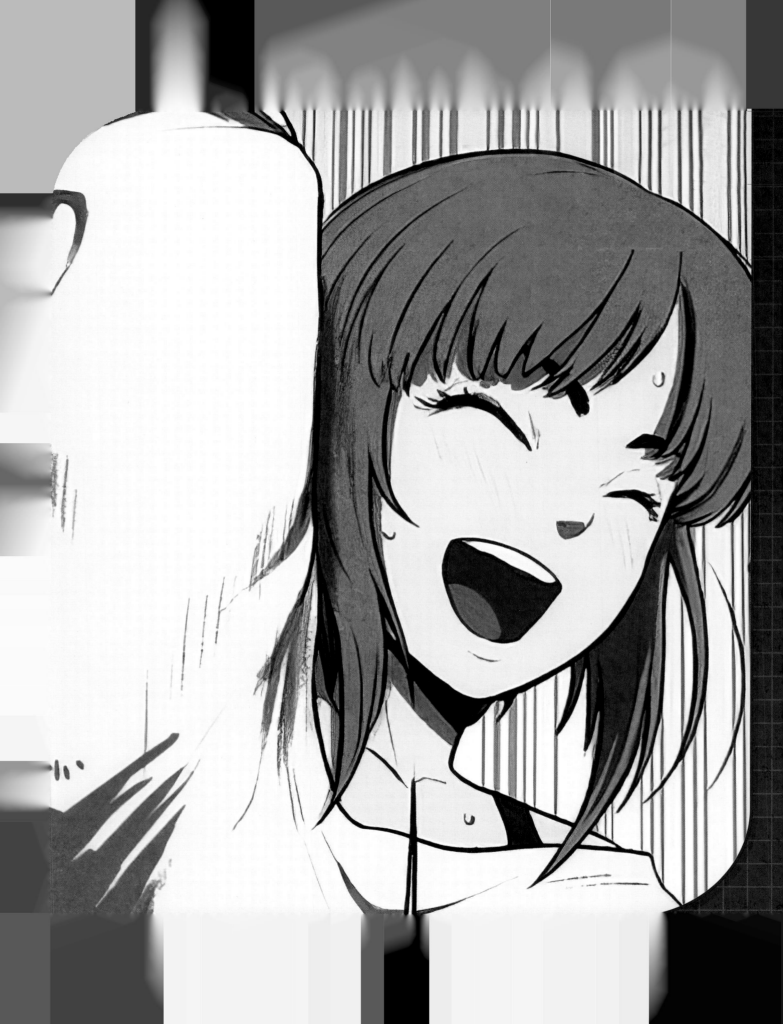

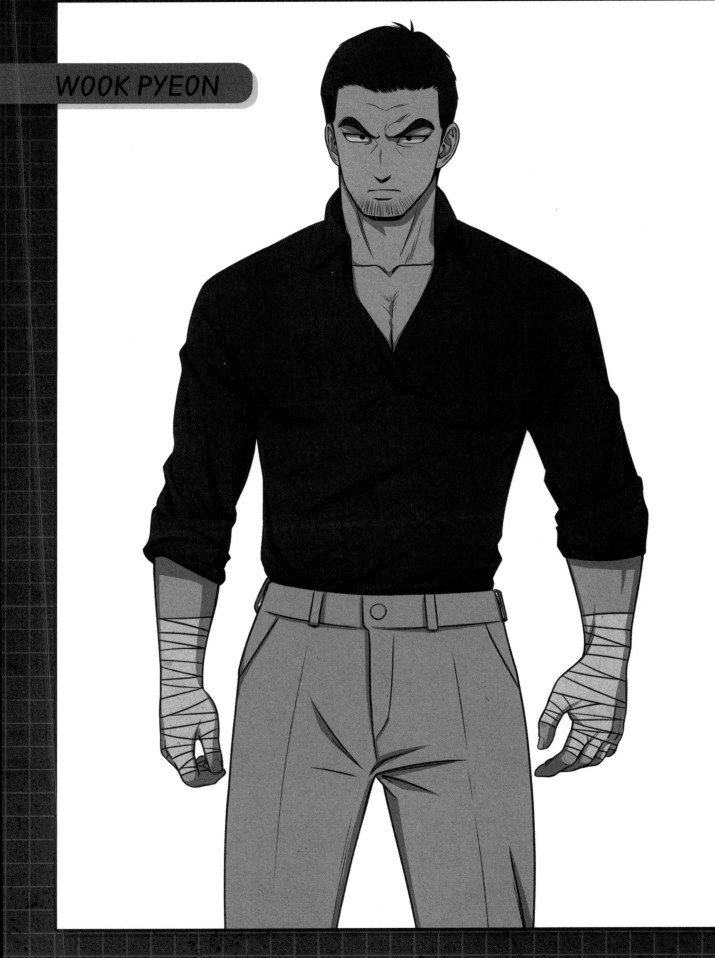

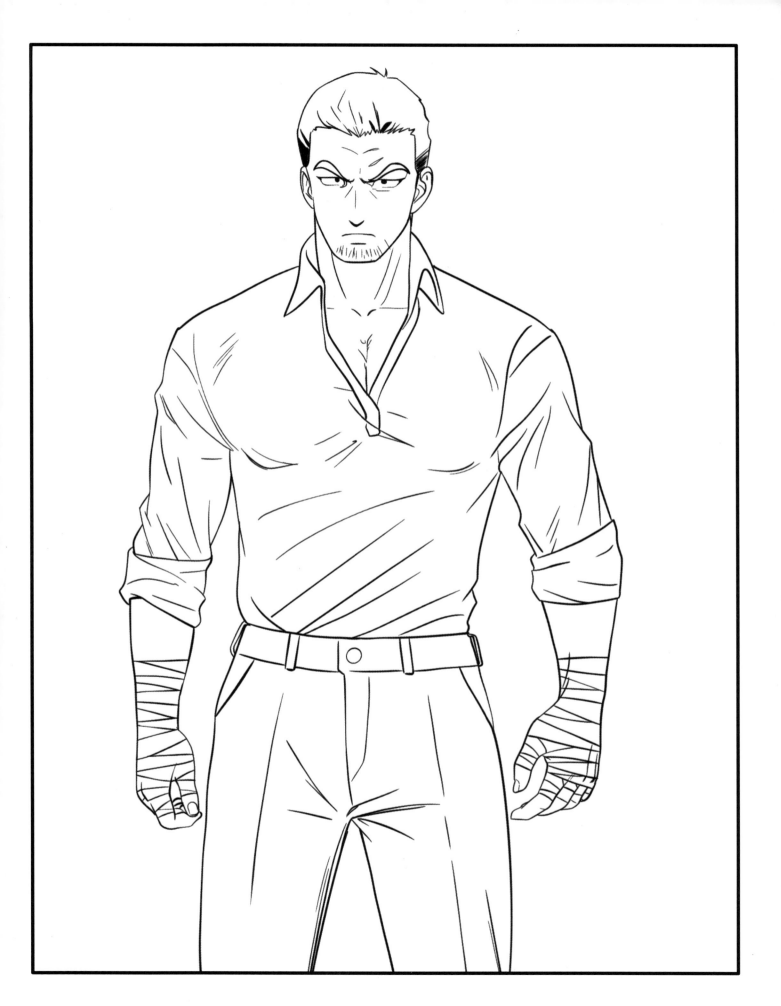

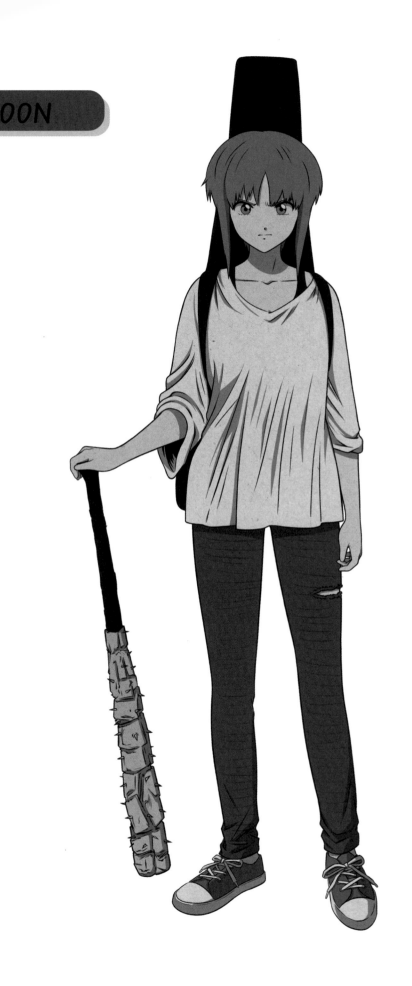

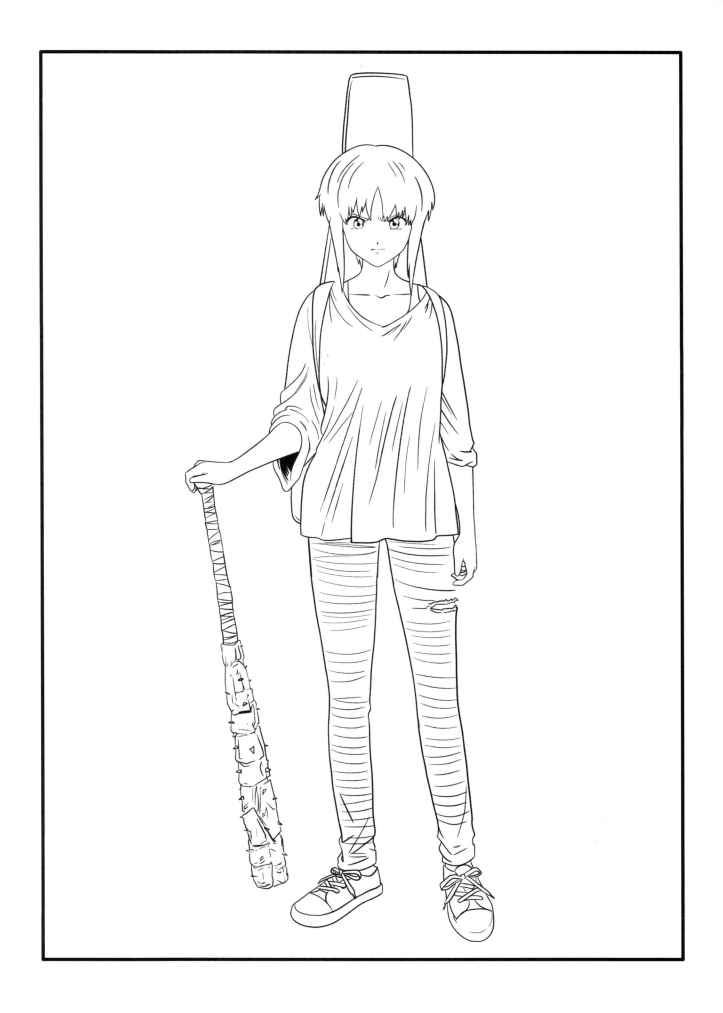

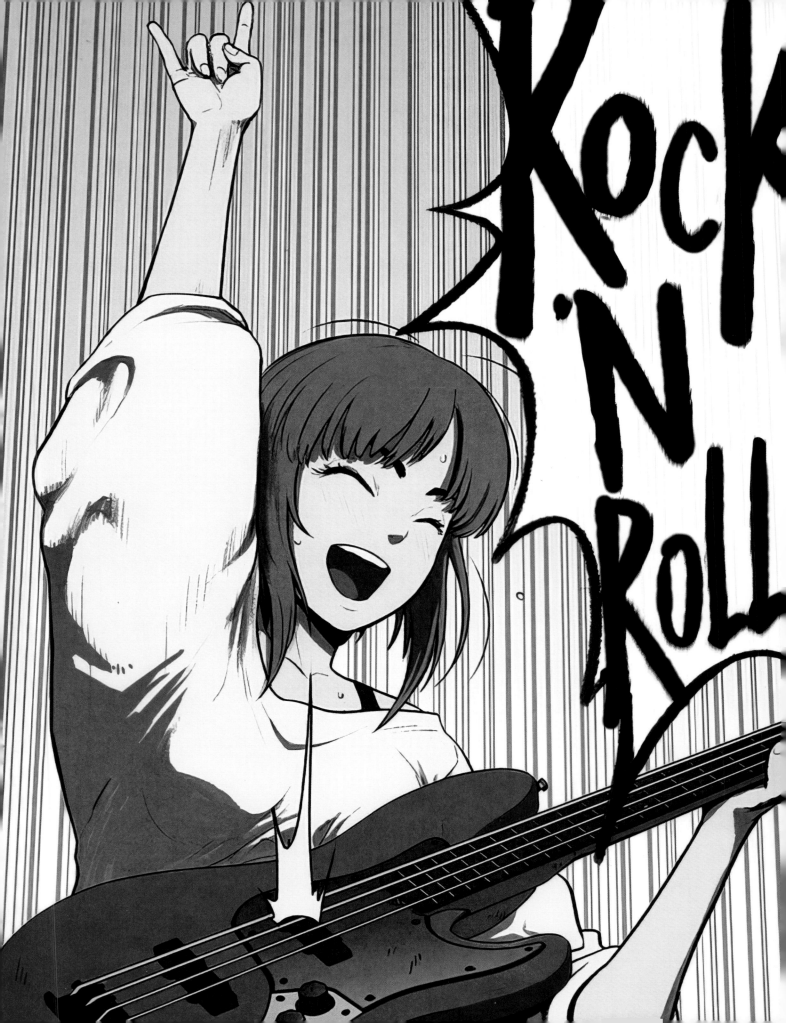

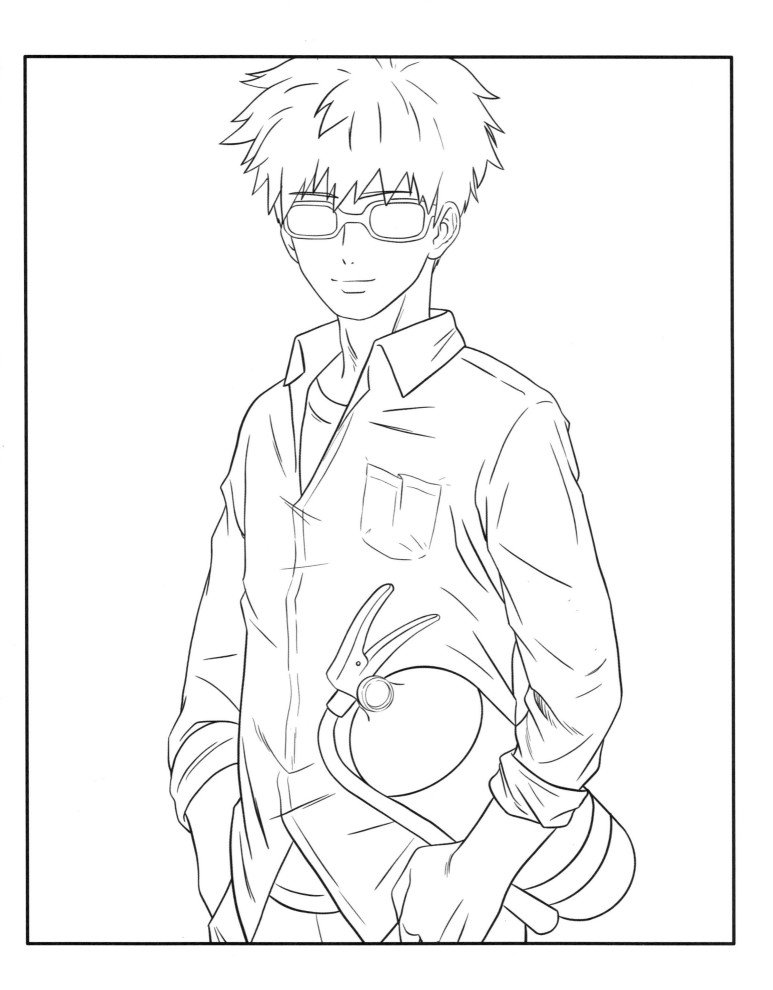

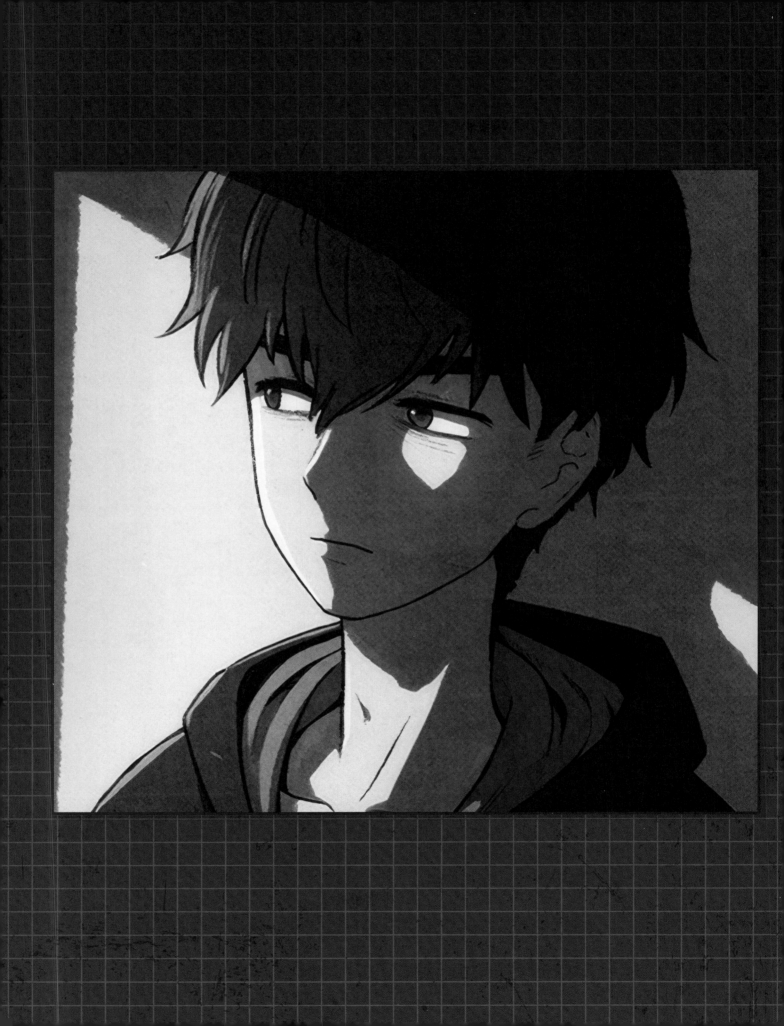

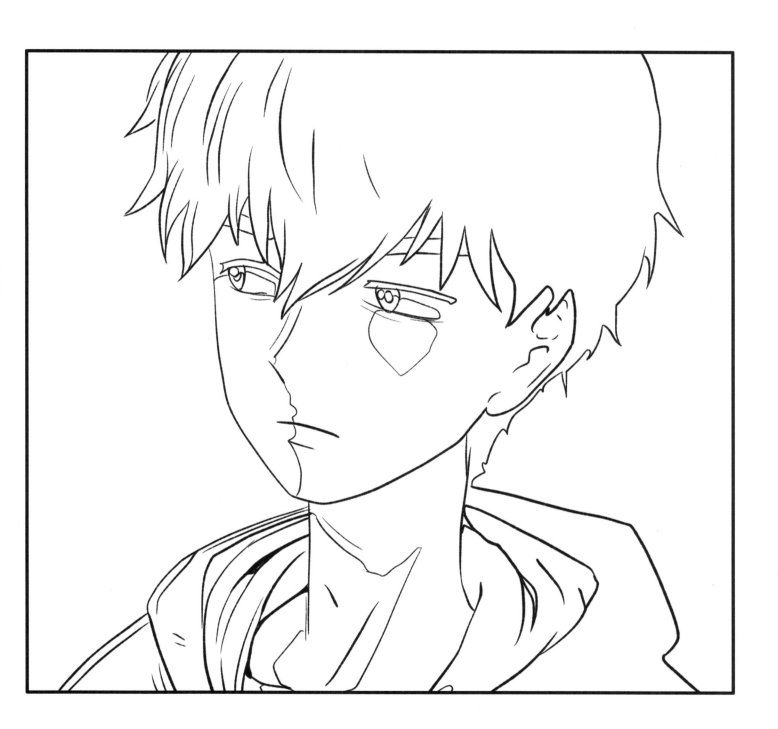

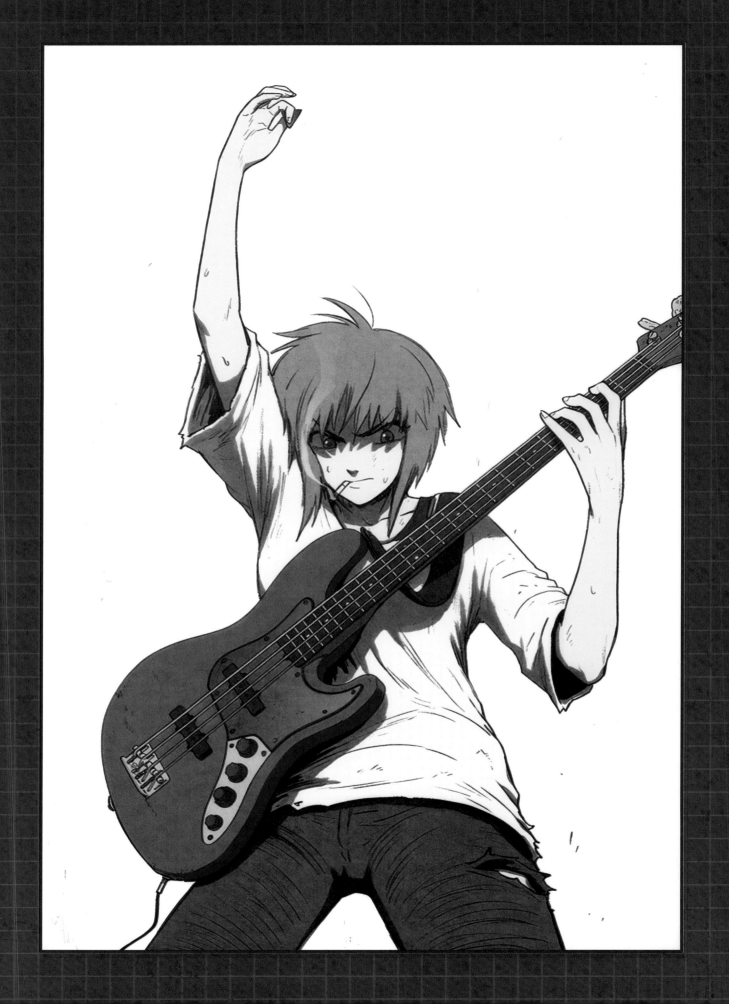

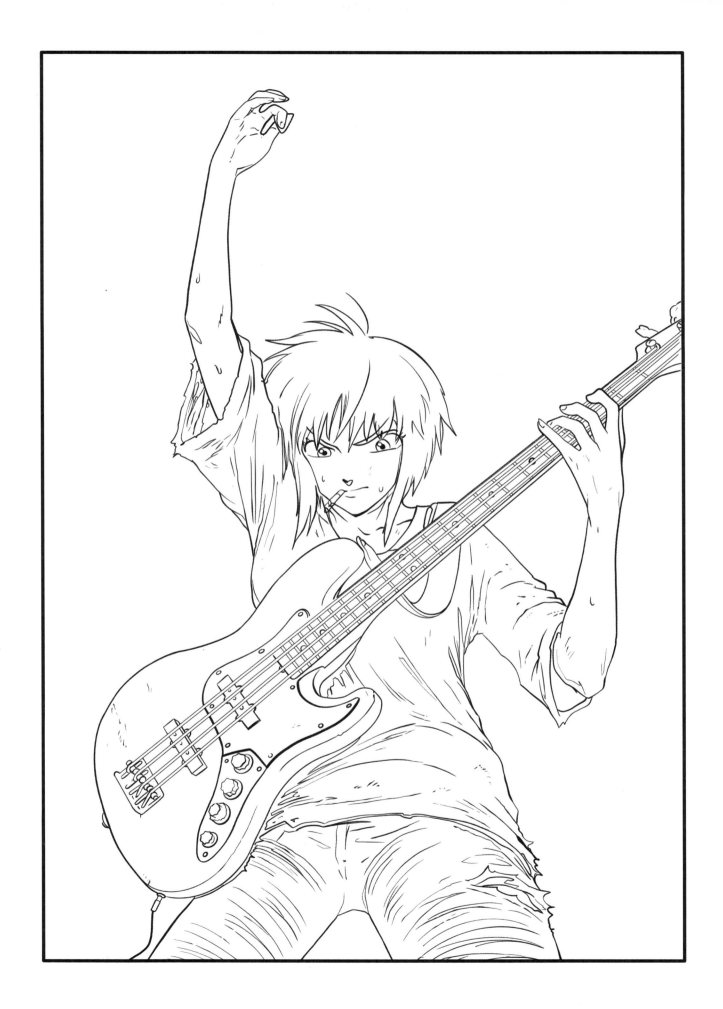

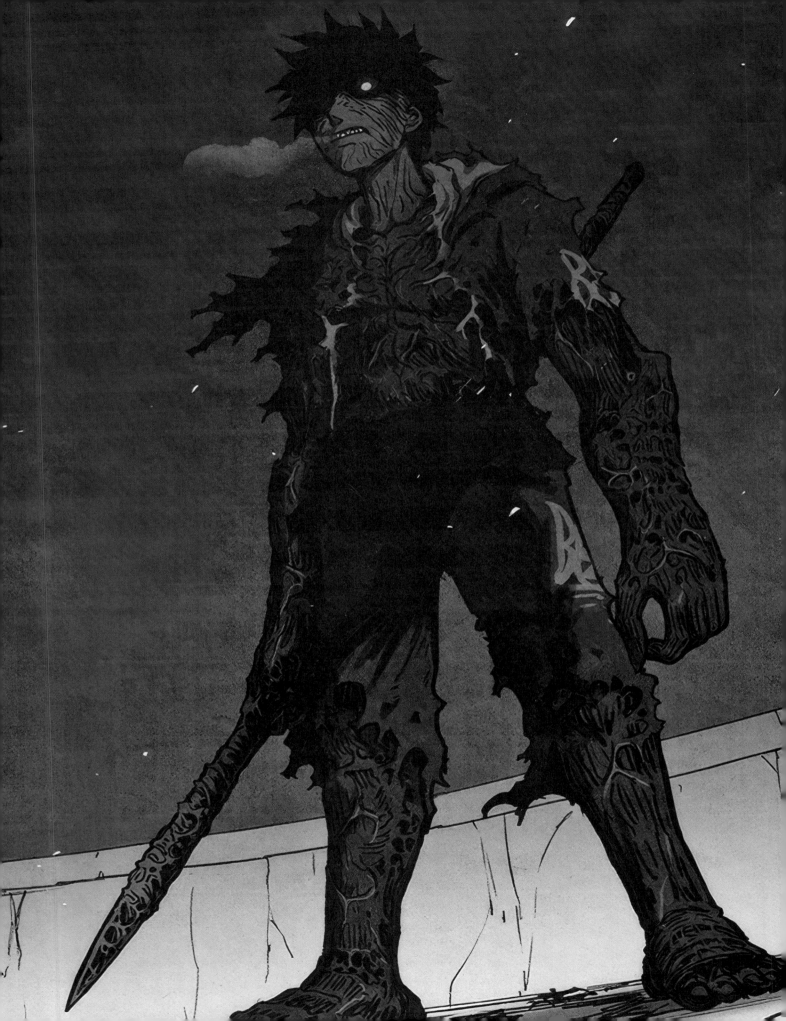

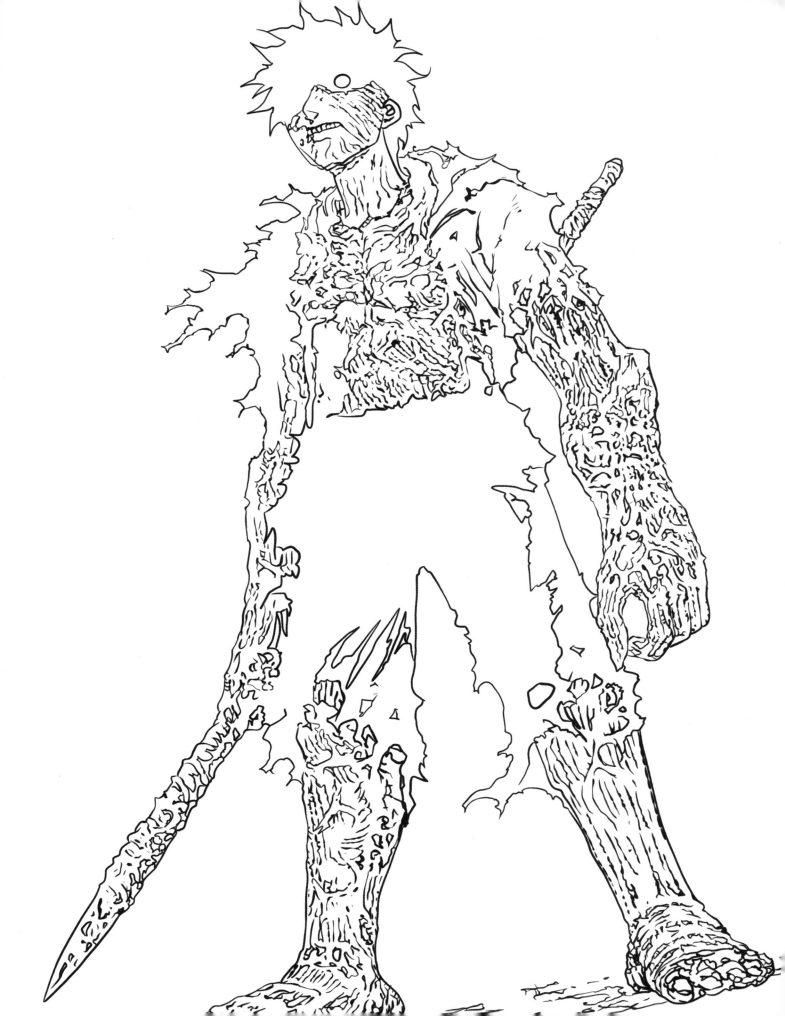

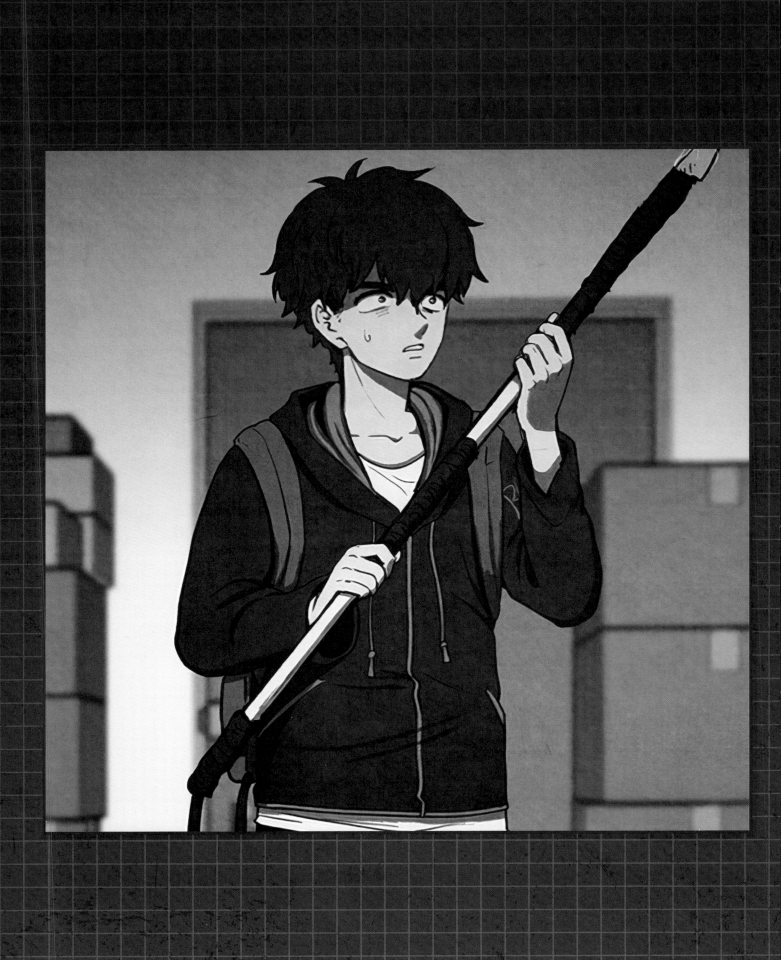

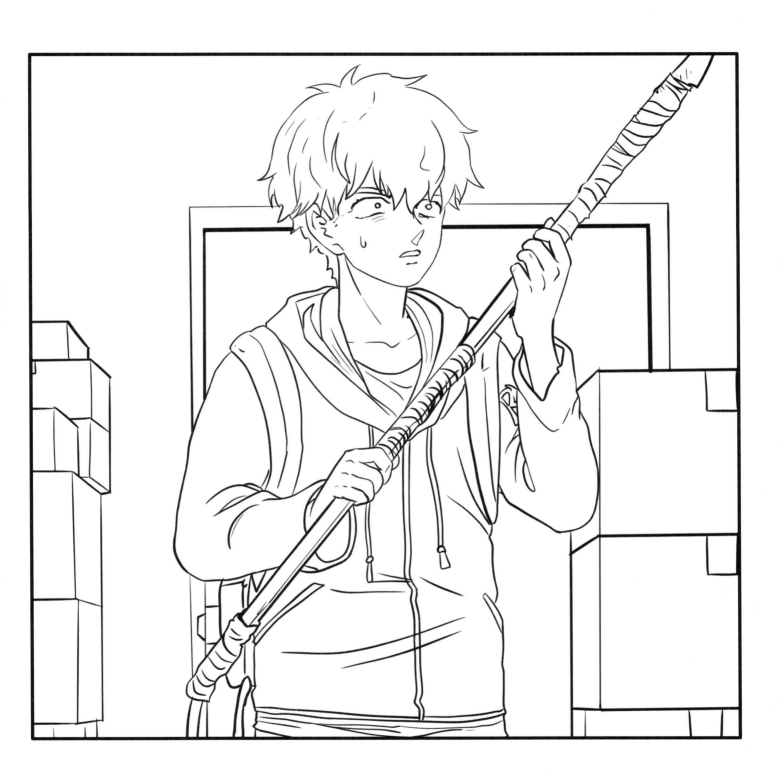

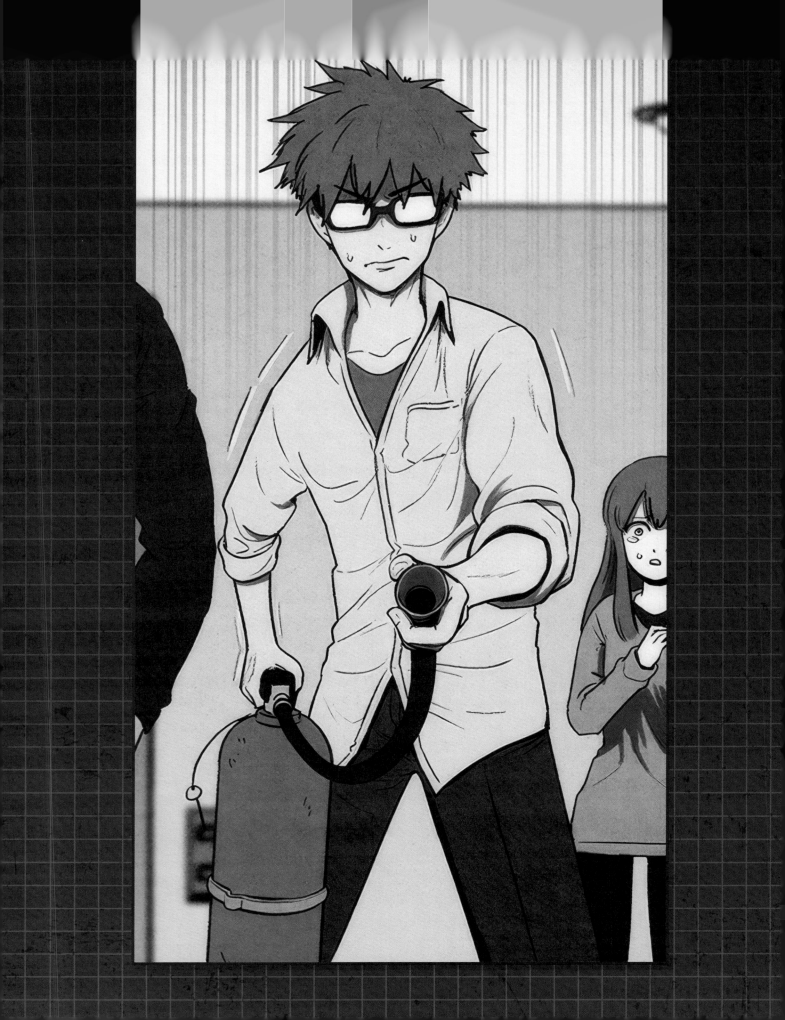

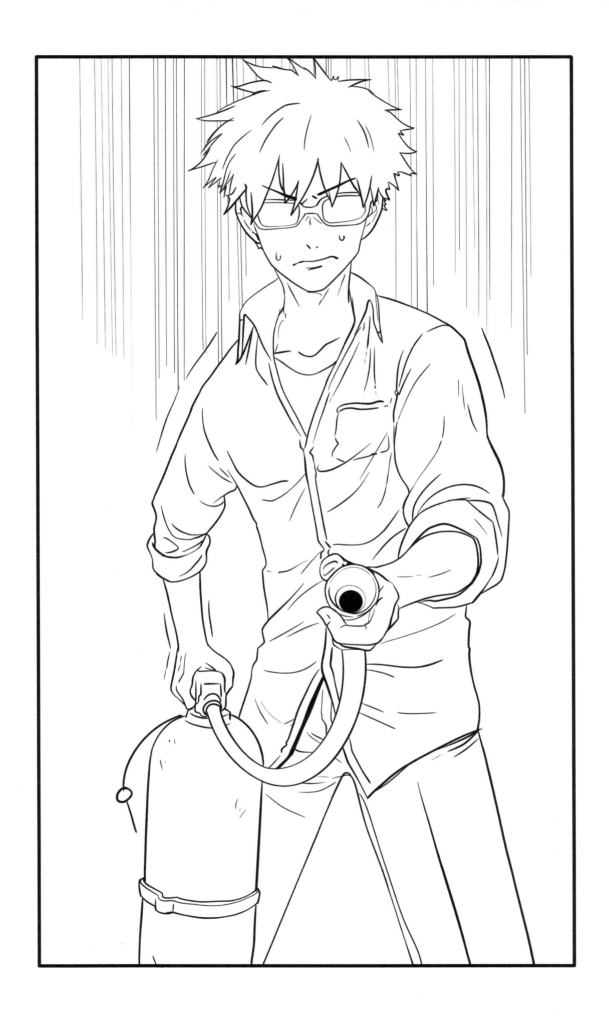

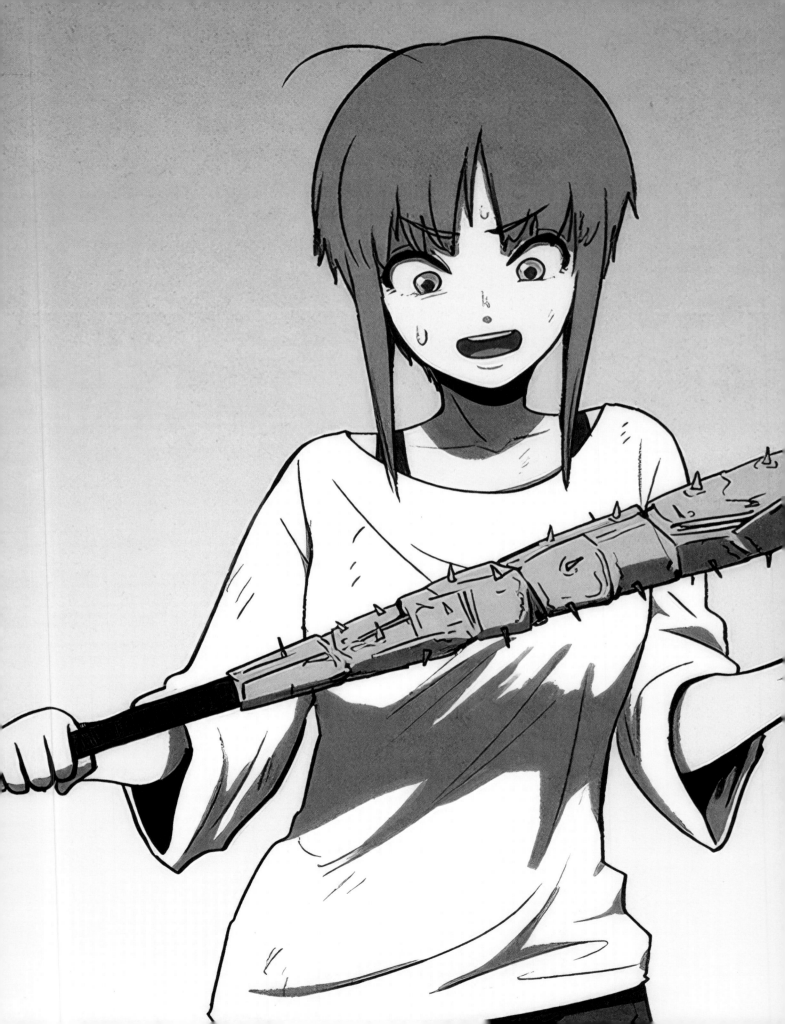

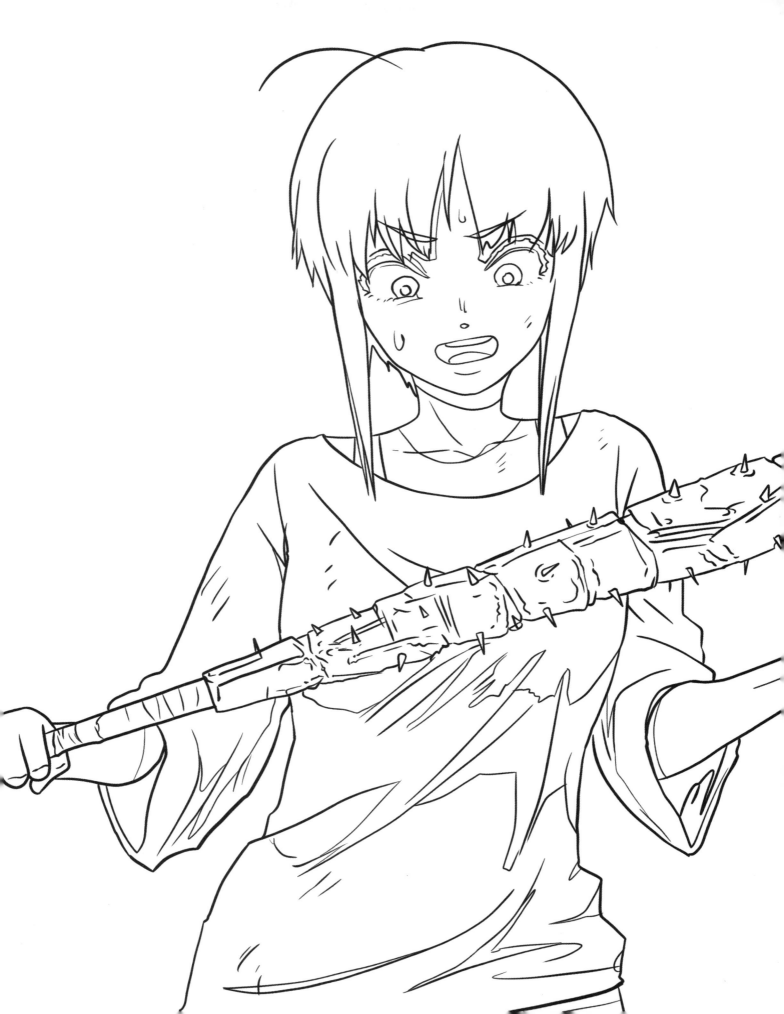

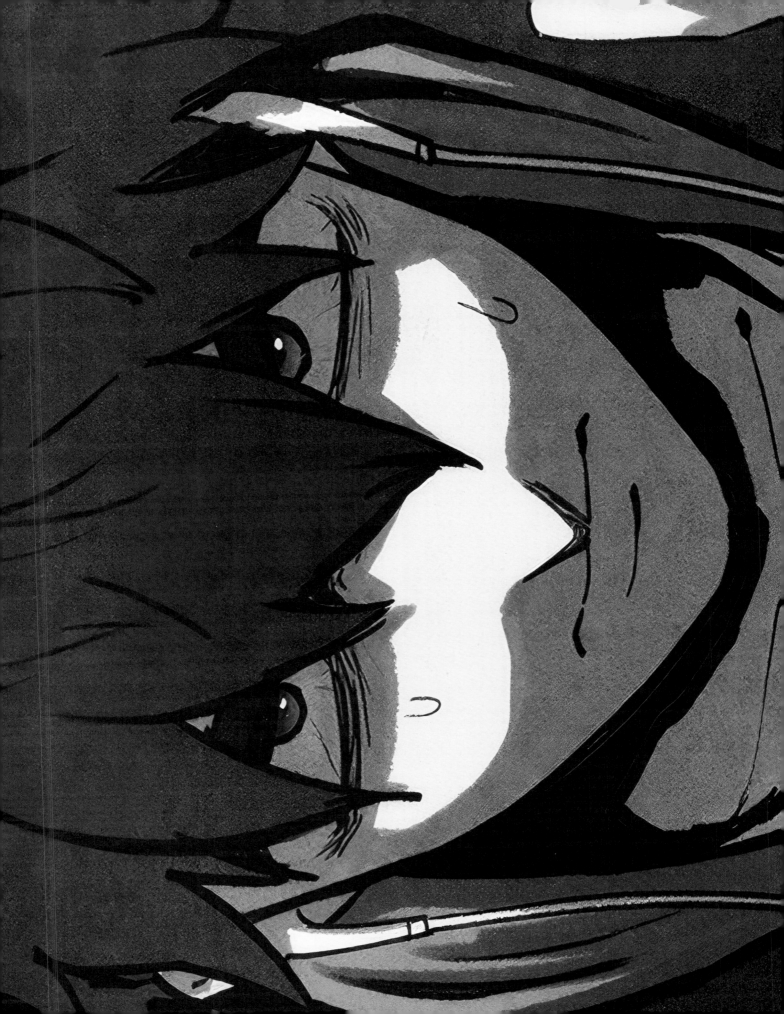

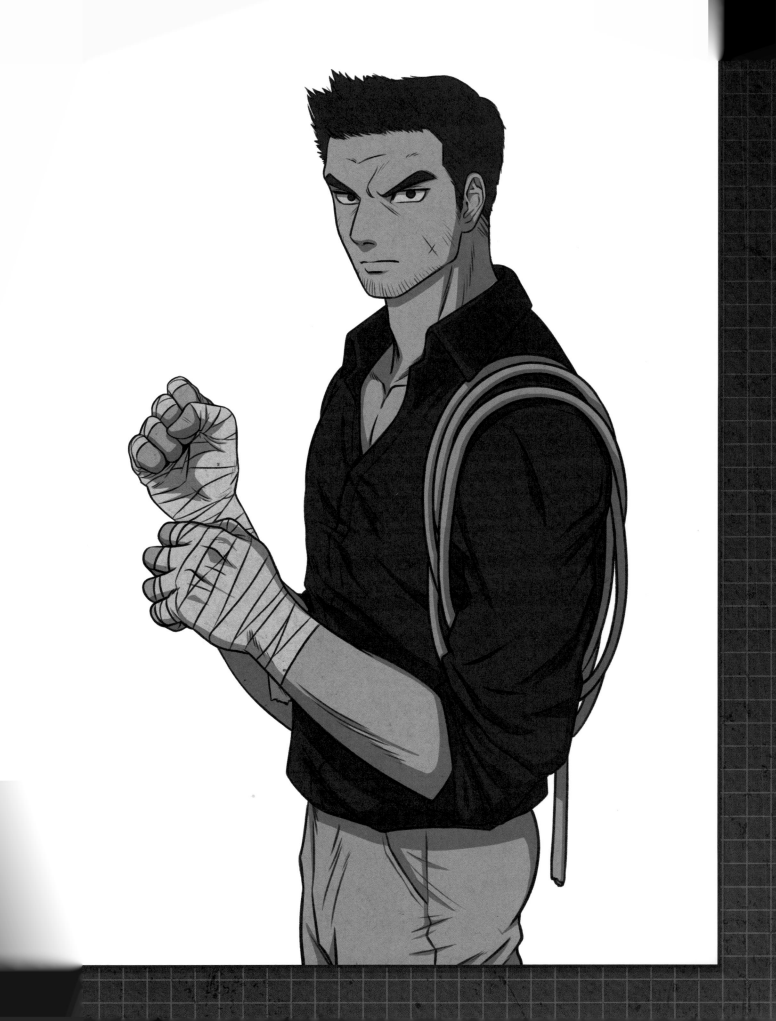

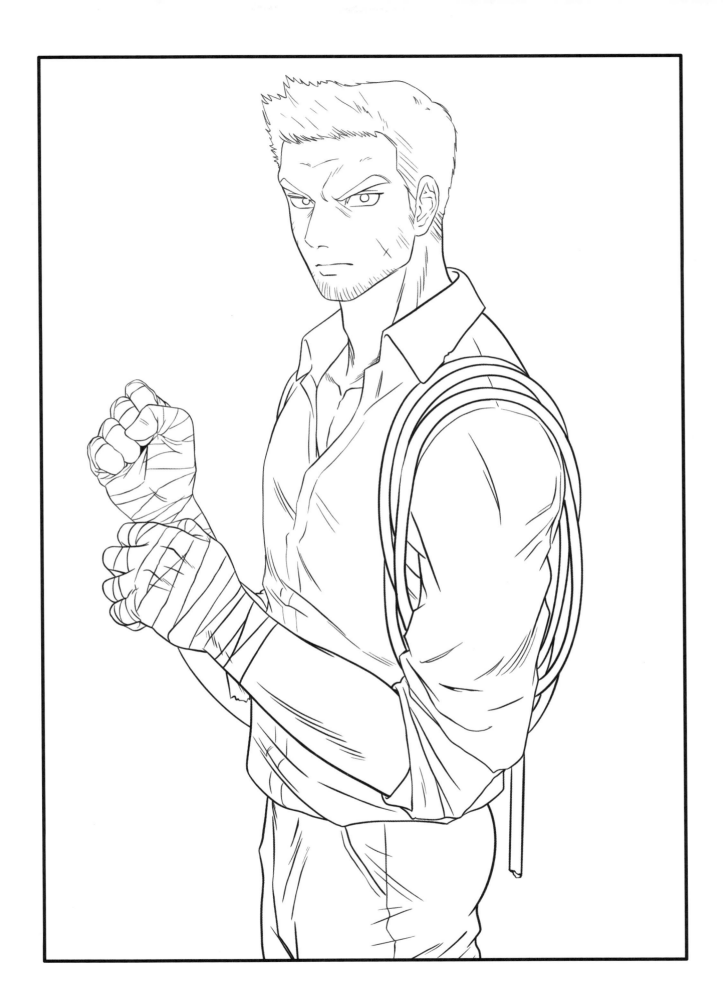

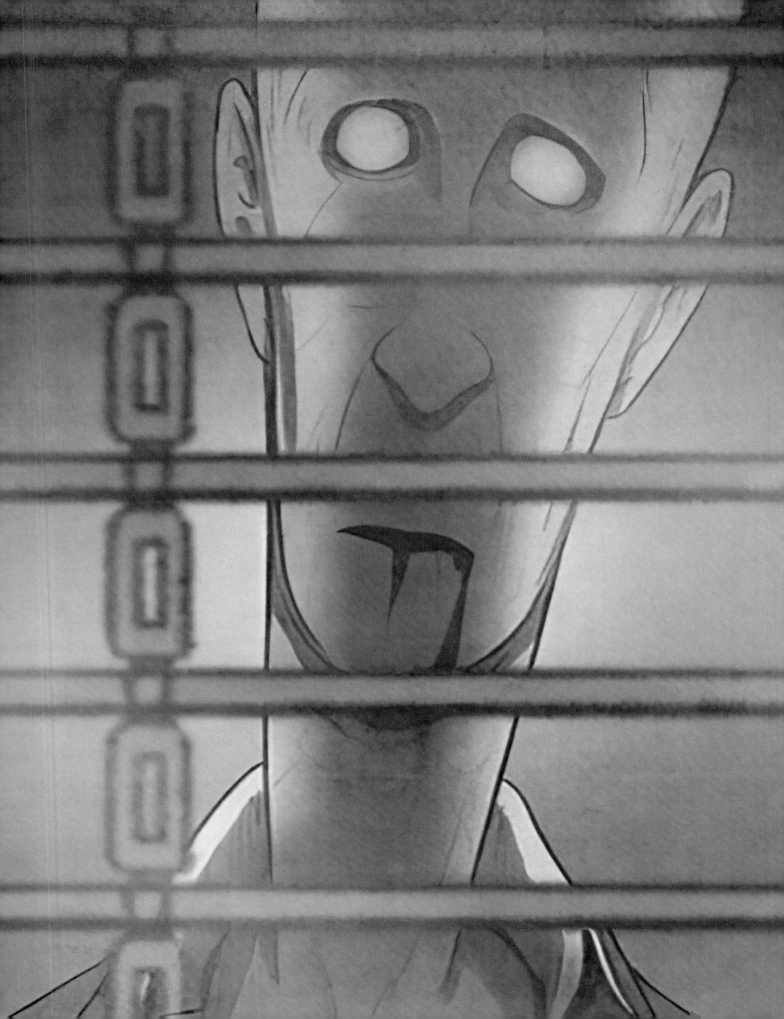

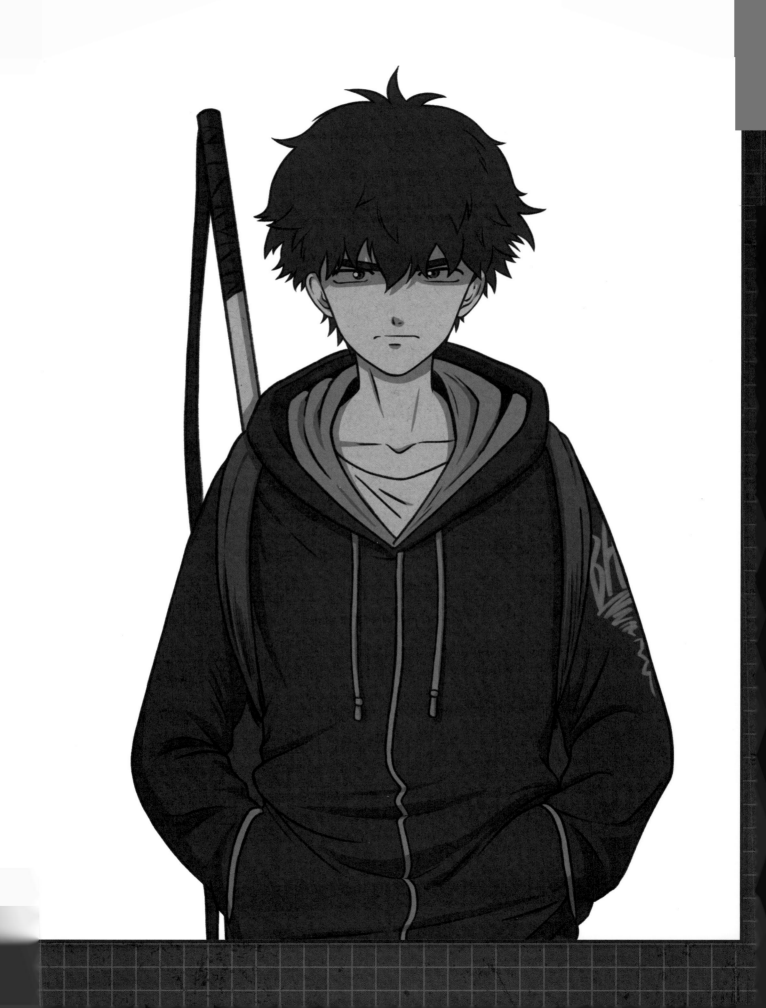

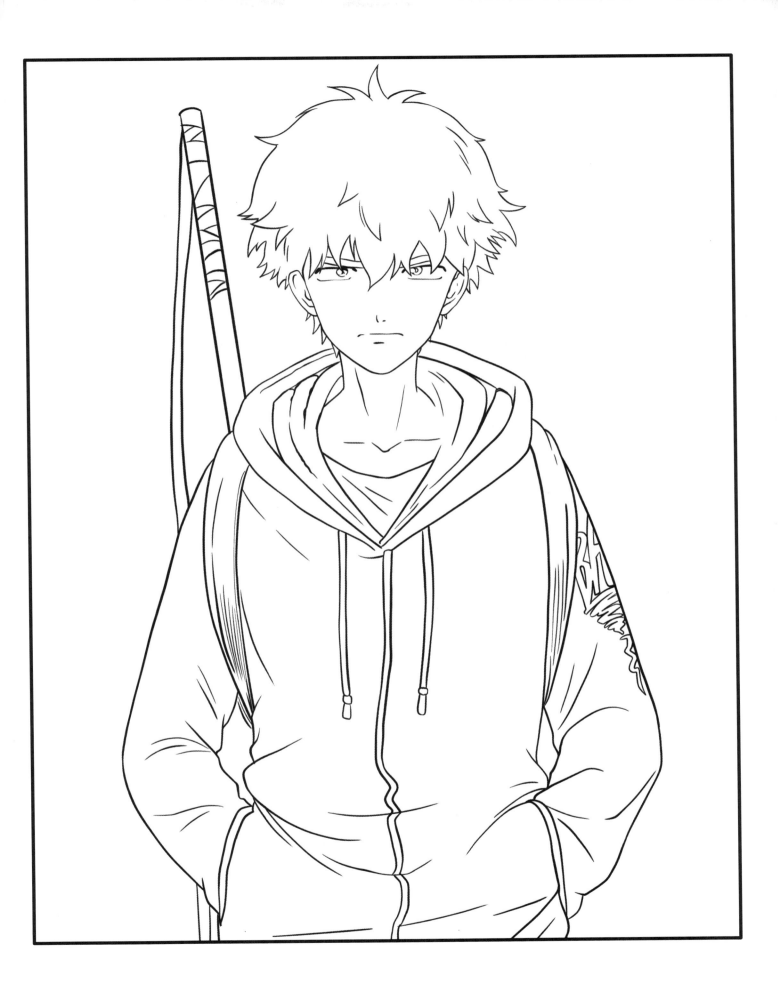

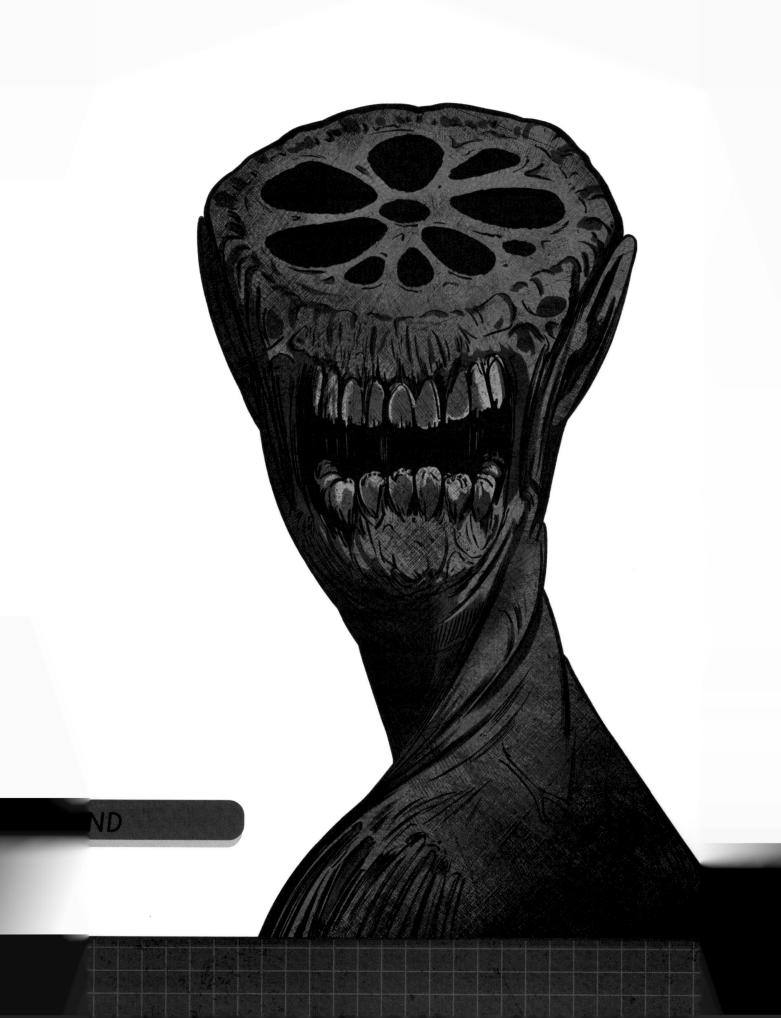

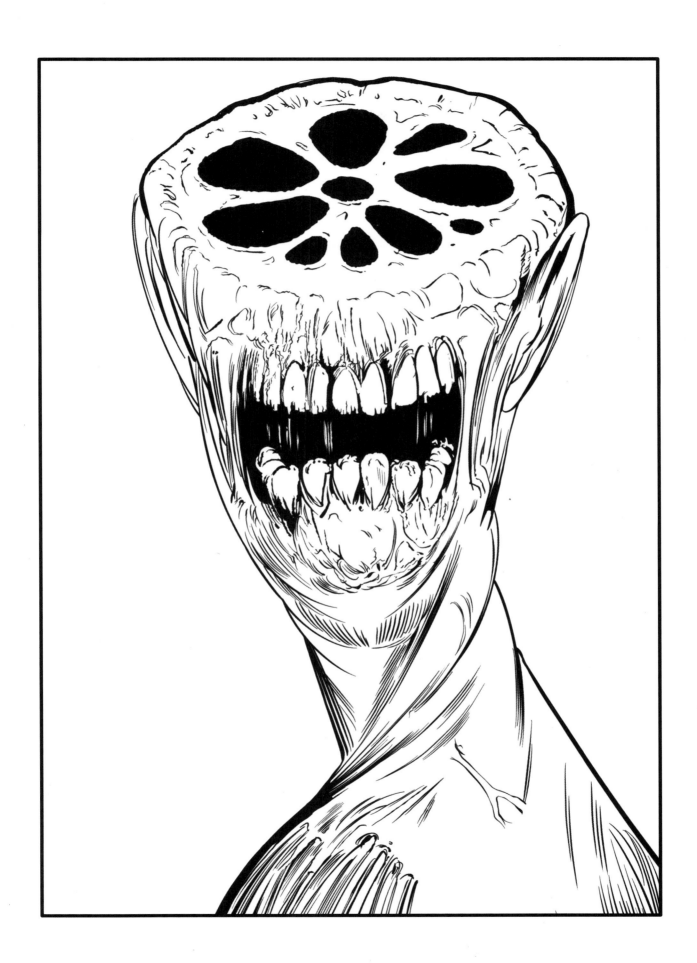

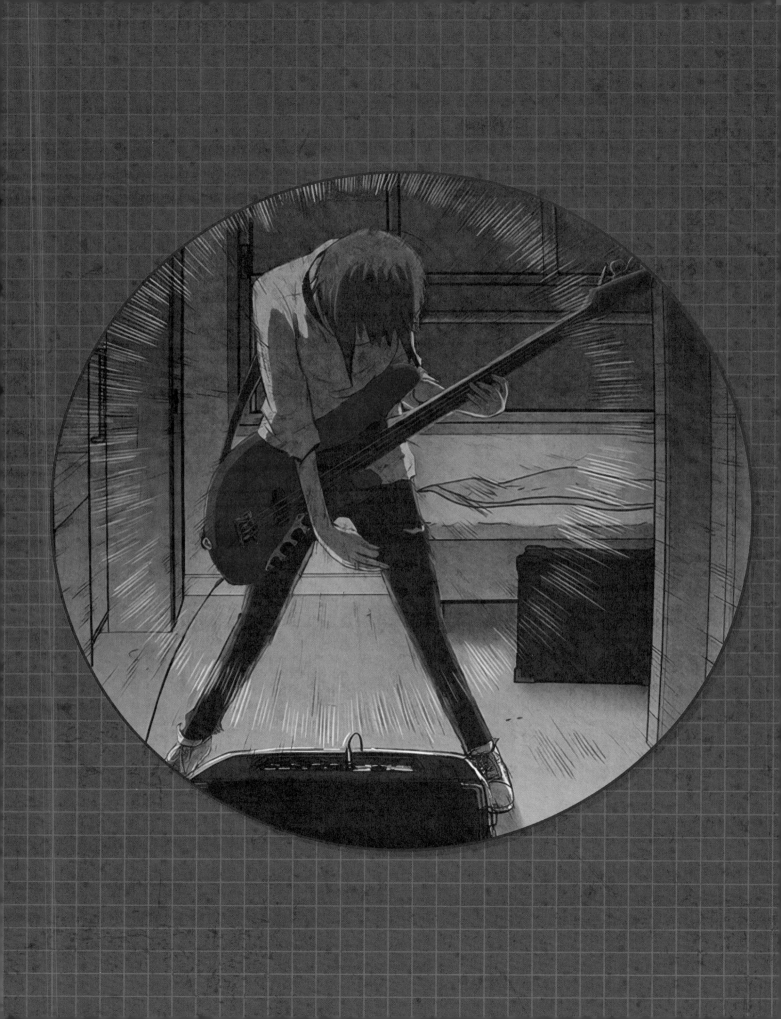

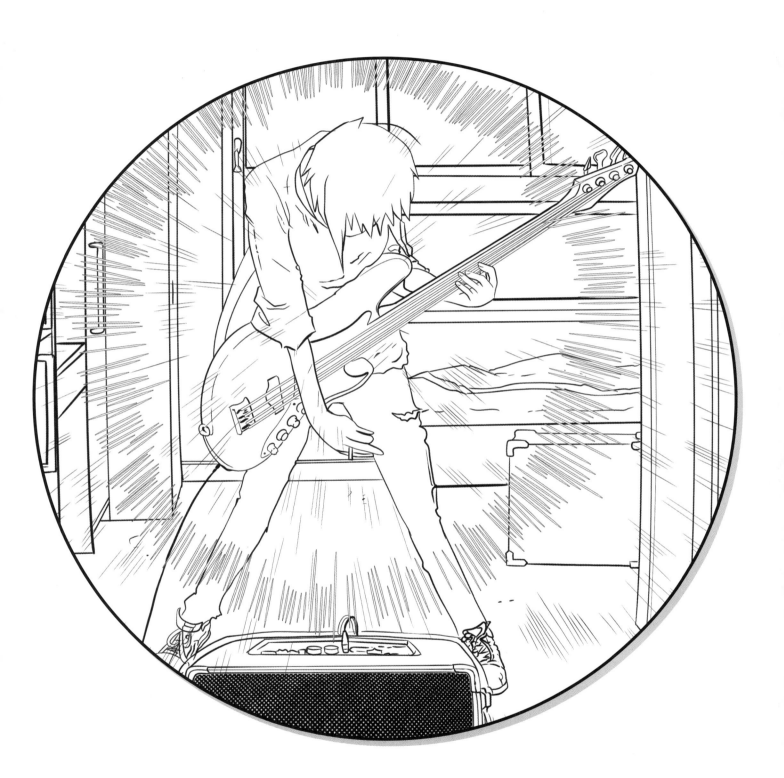

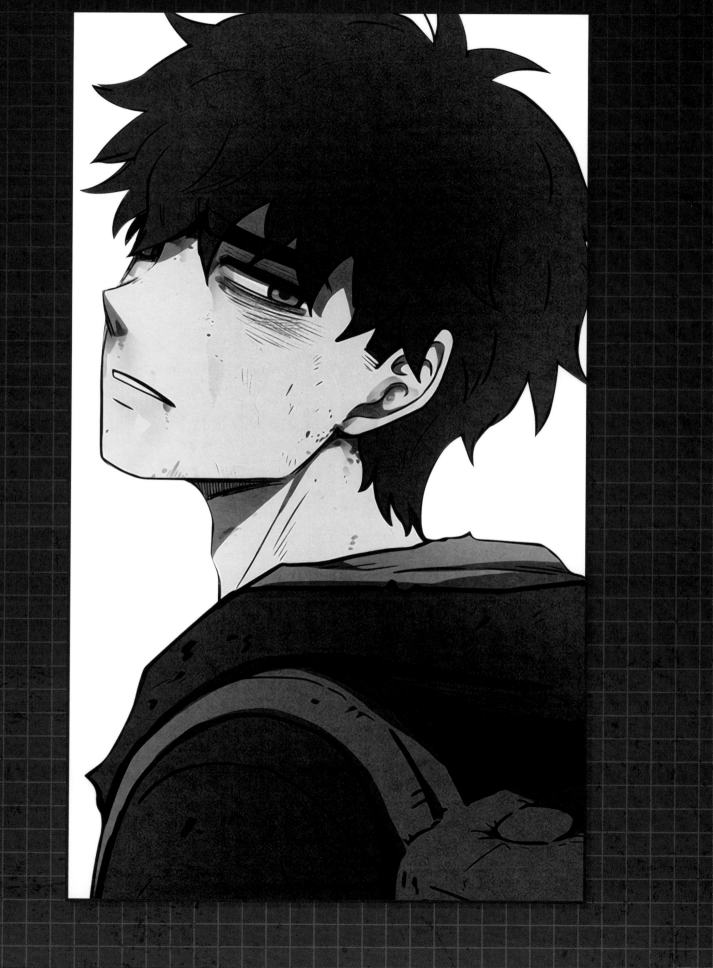

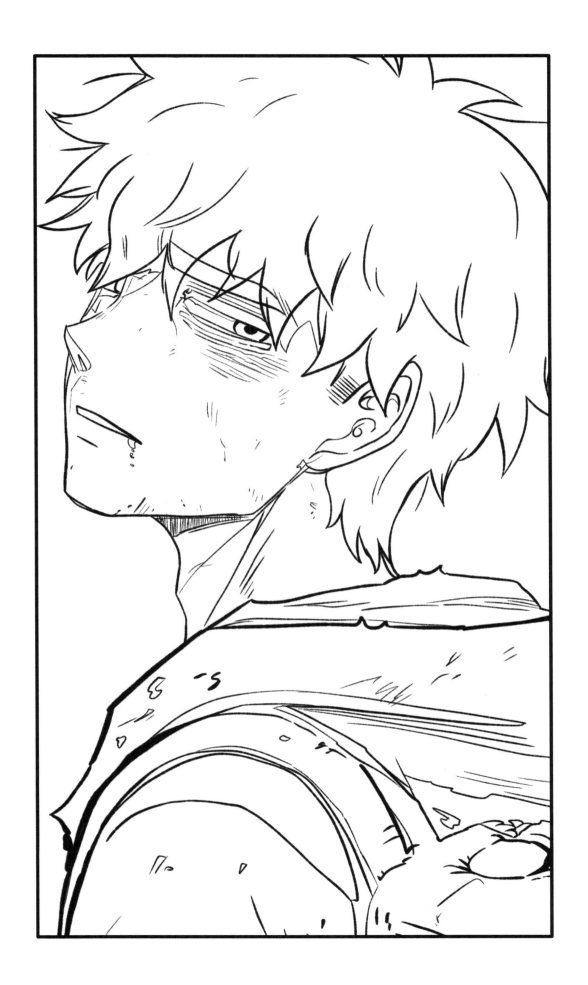

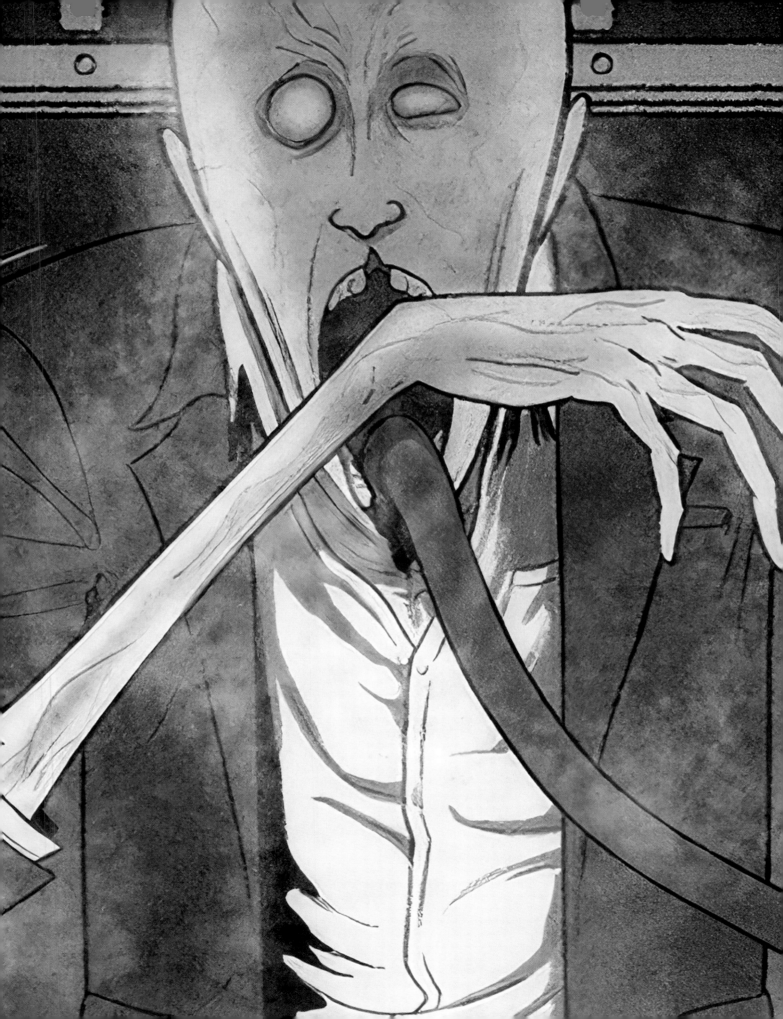

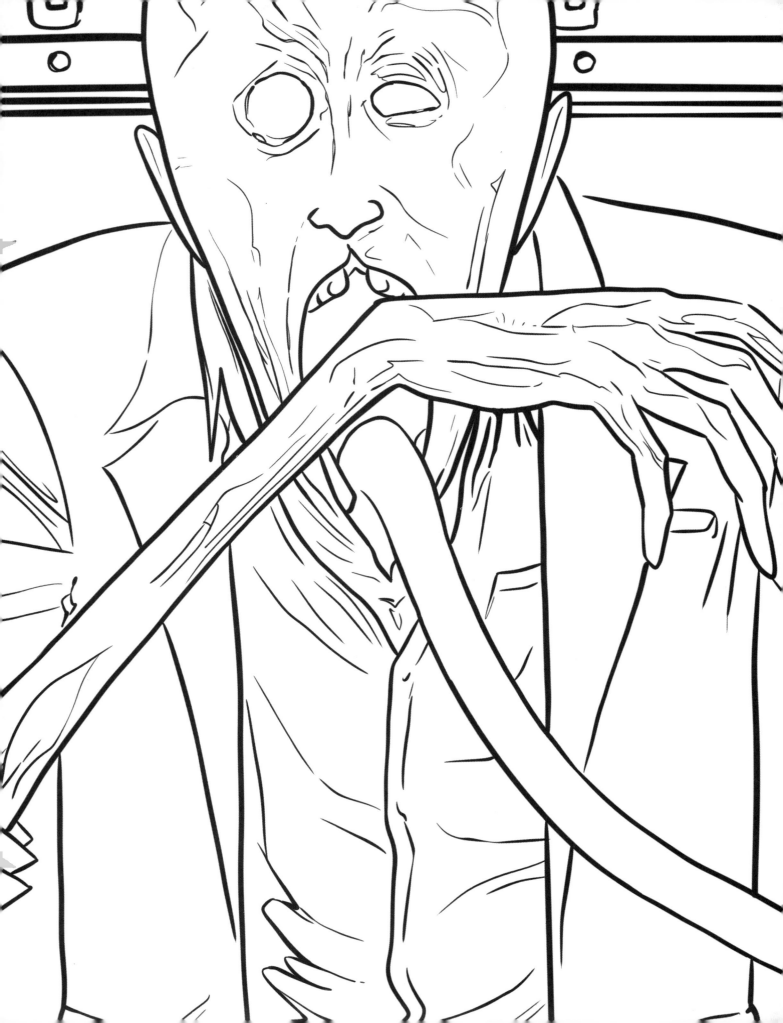

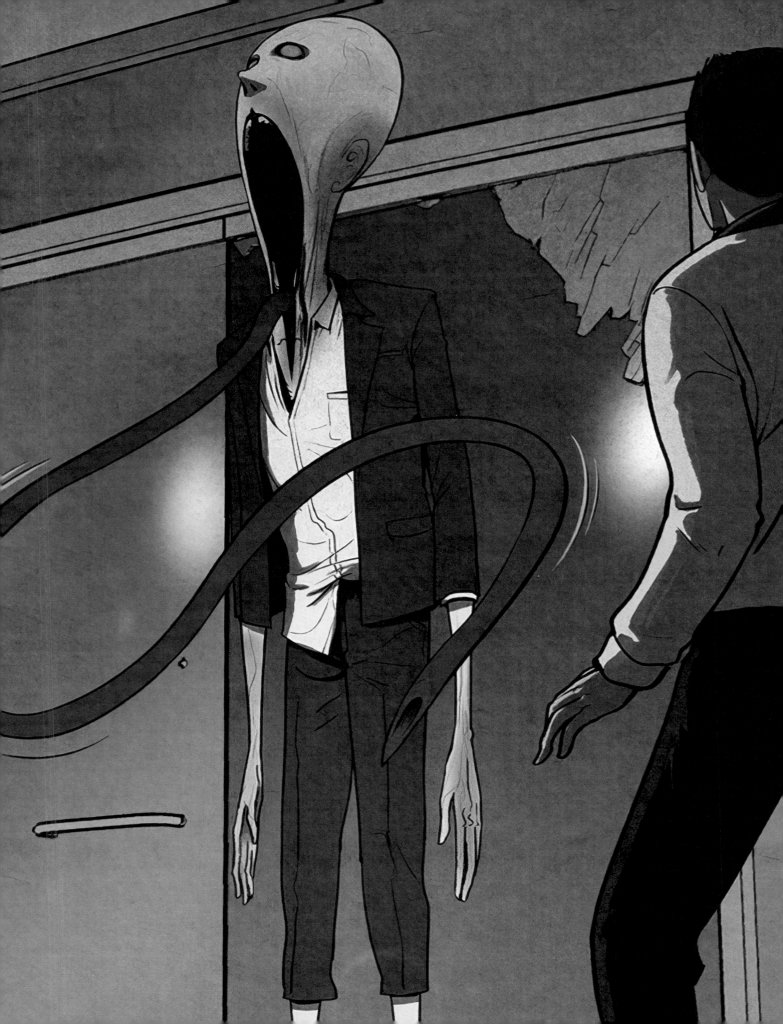

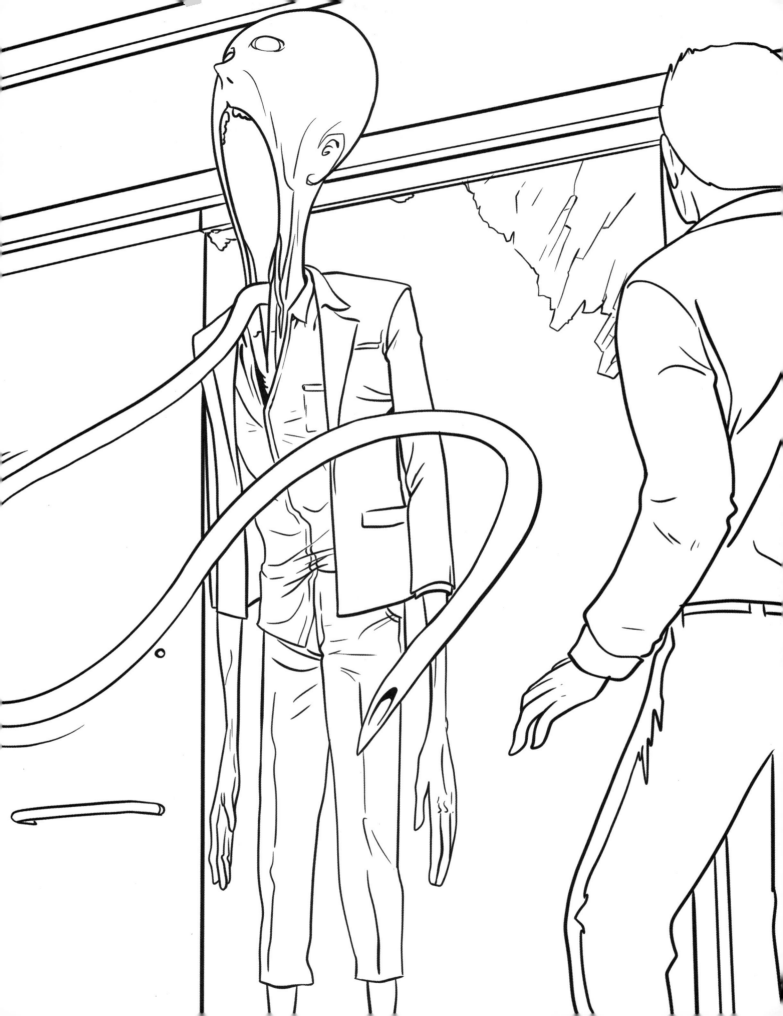

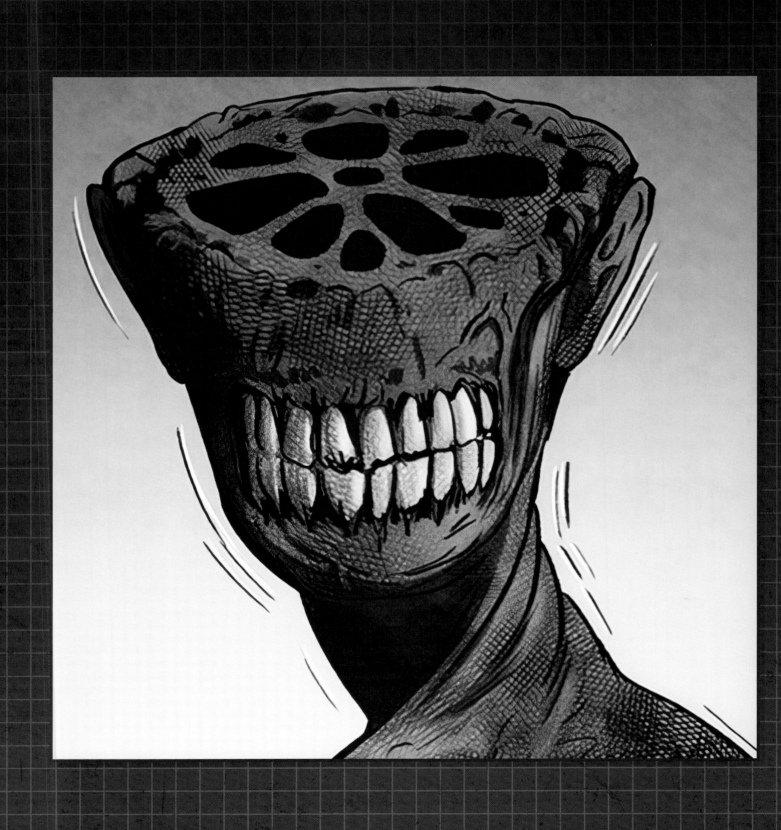

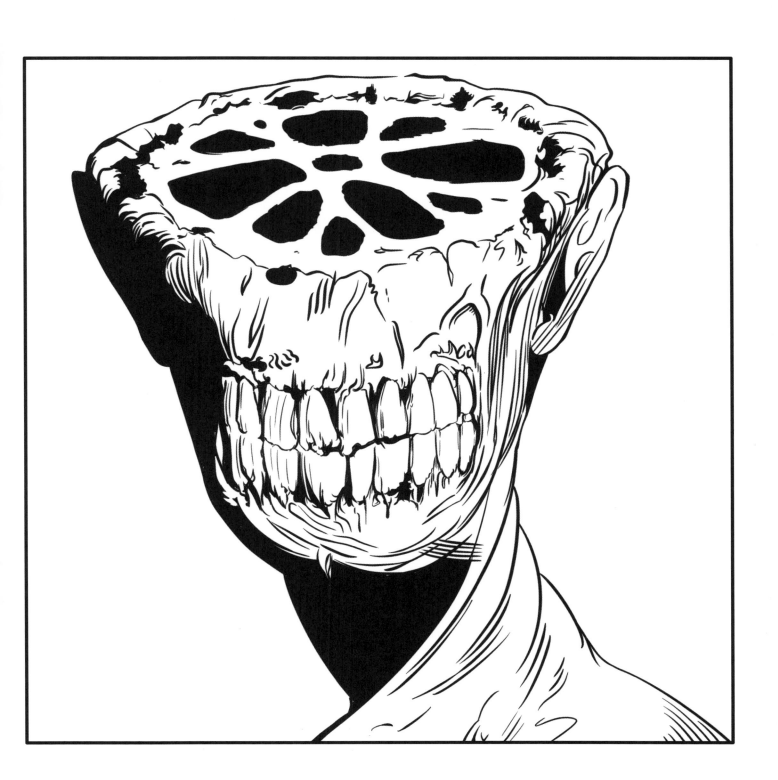

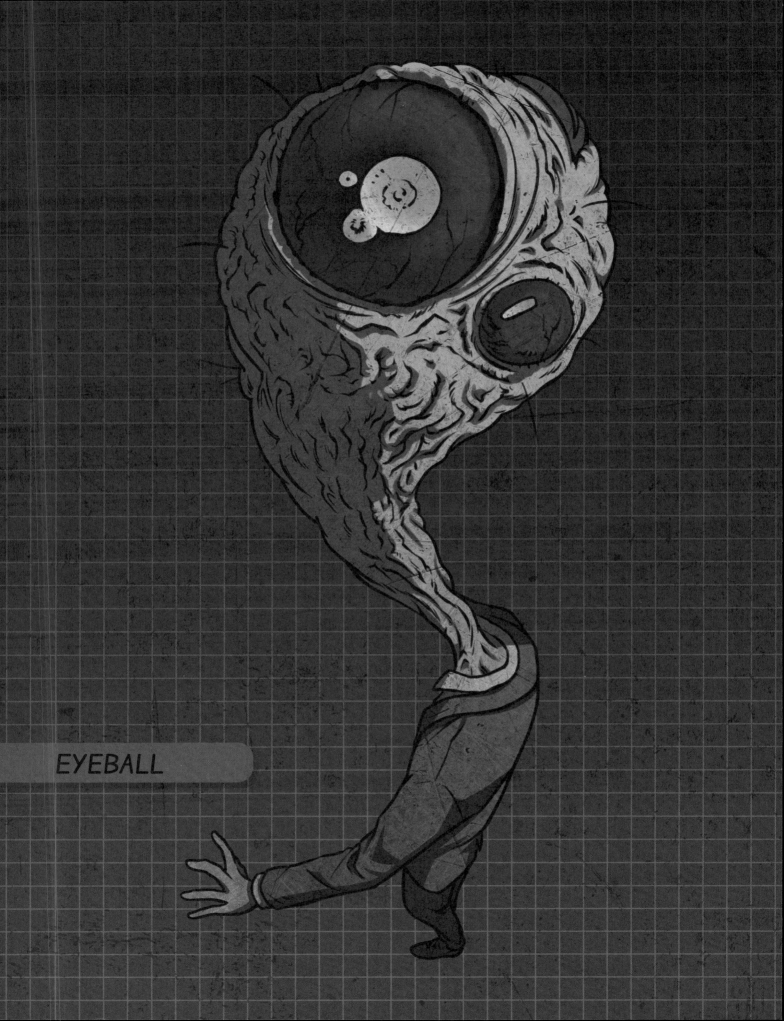

EYEBALL

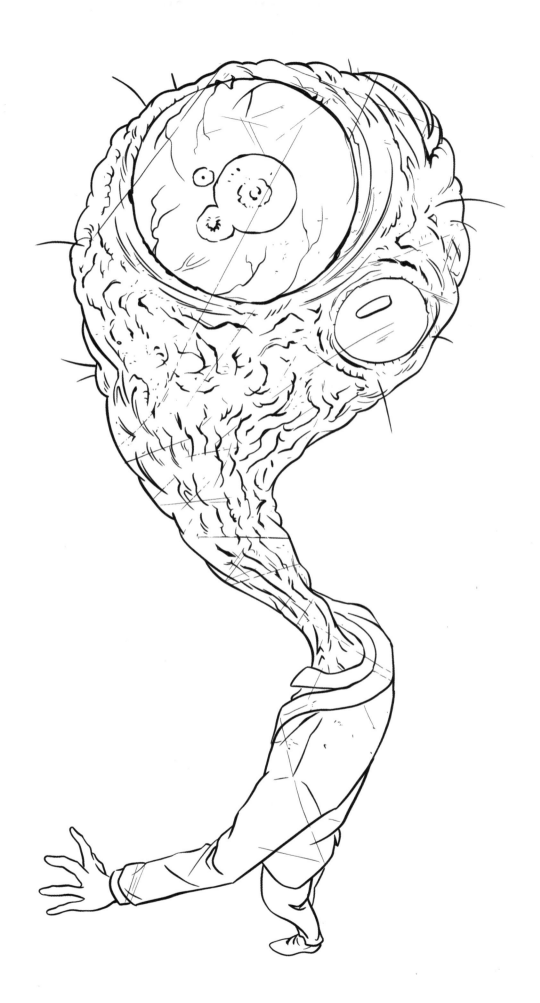

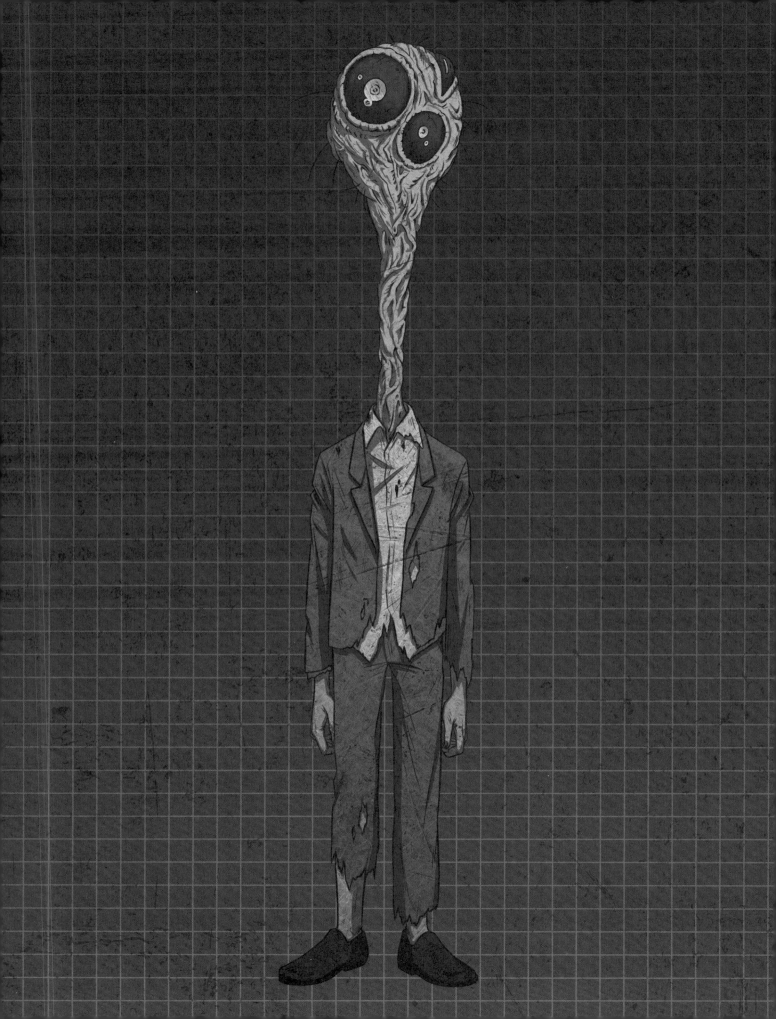

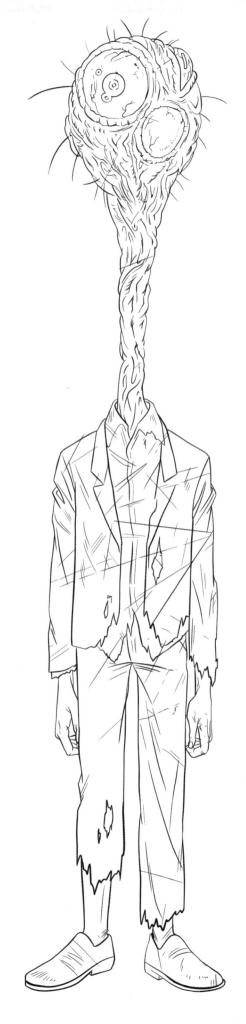

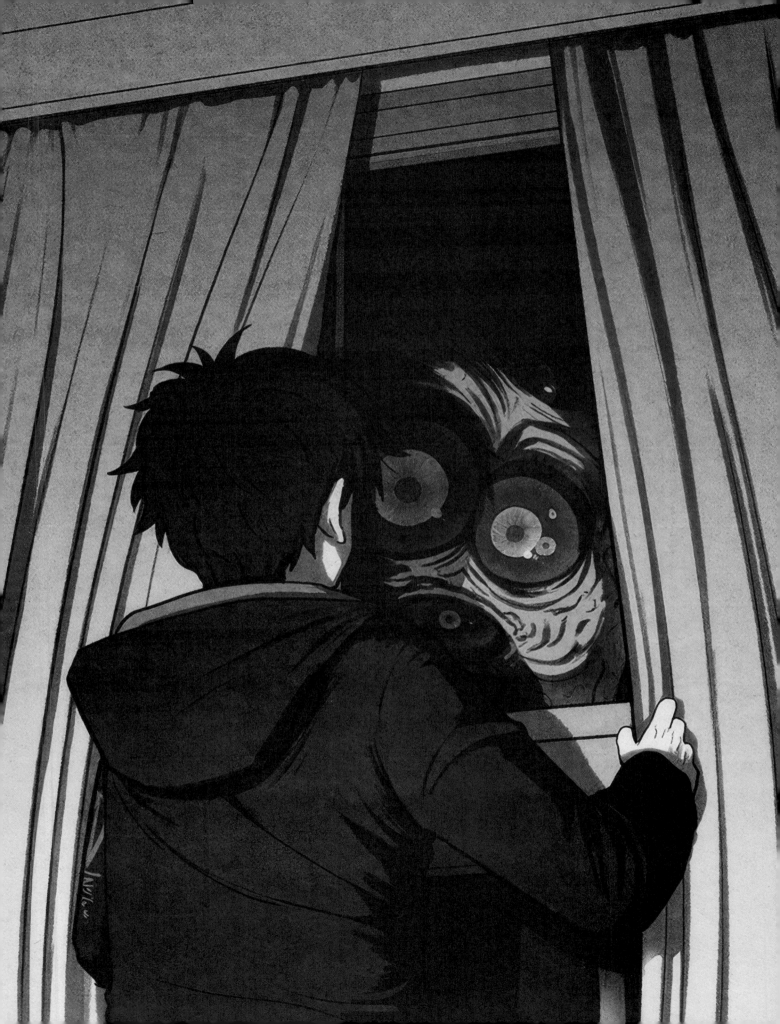

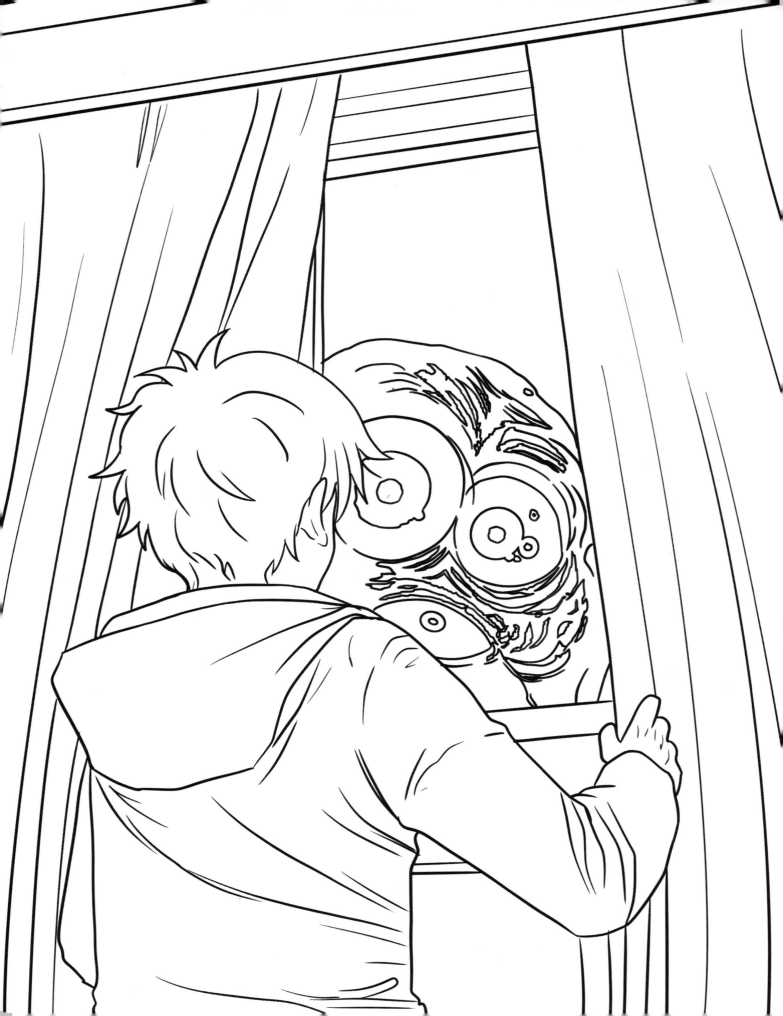

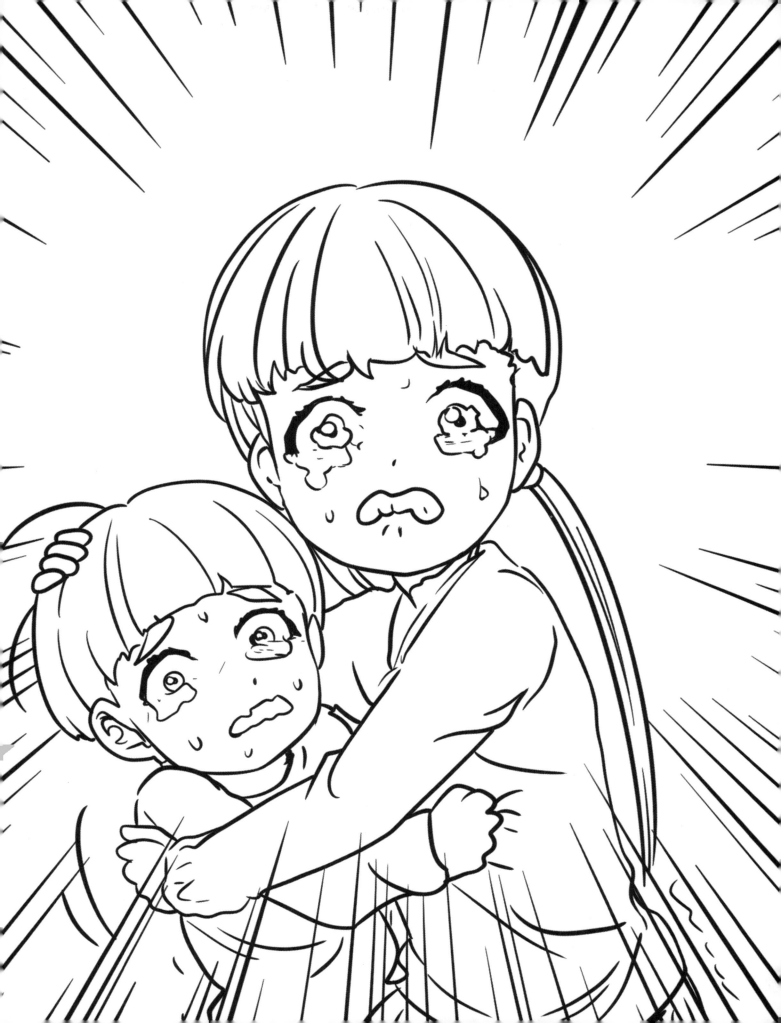

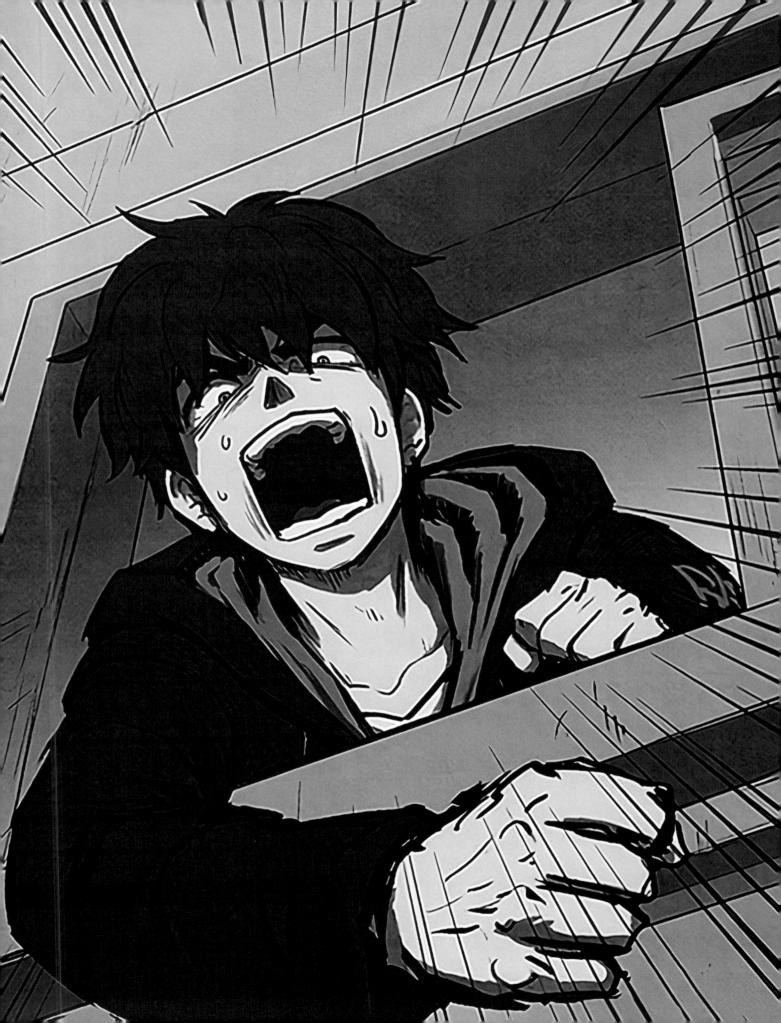

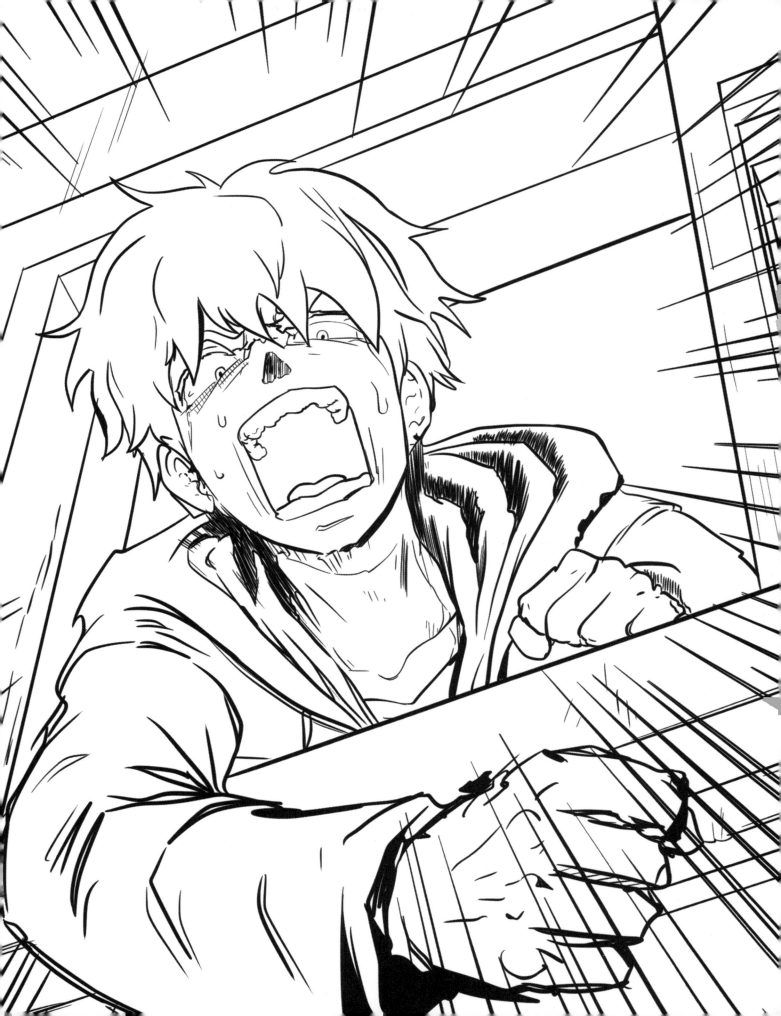

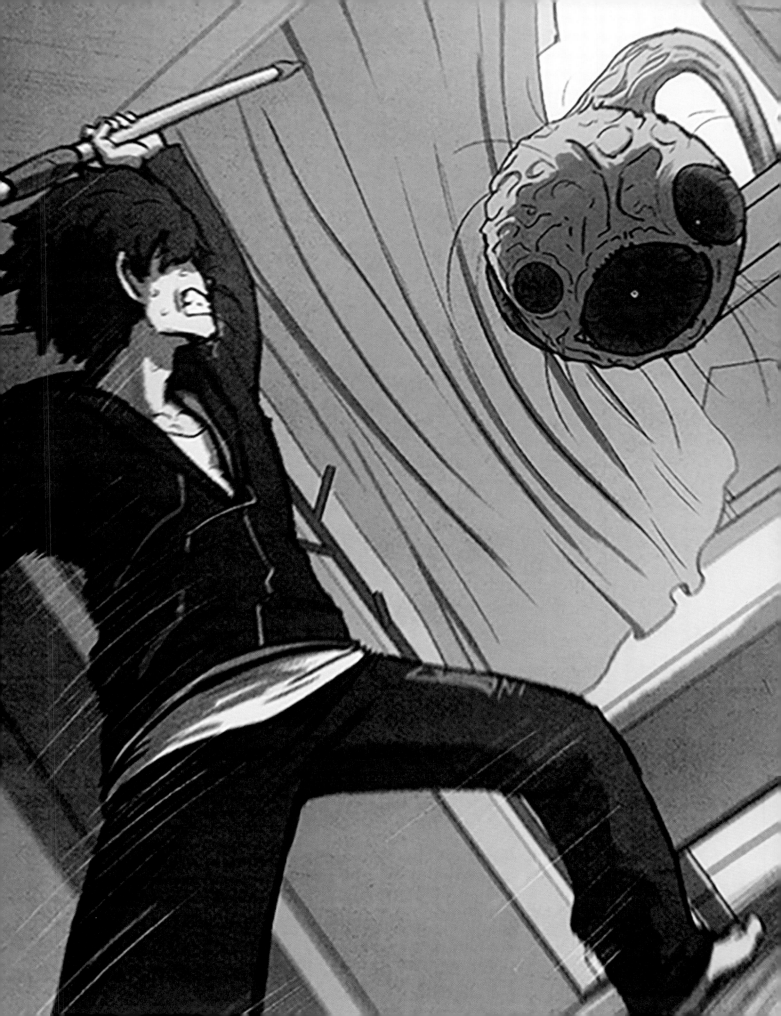

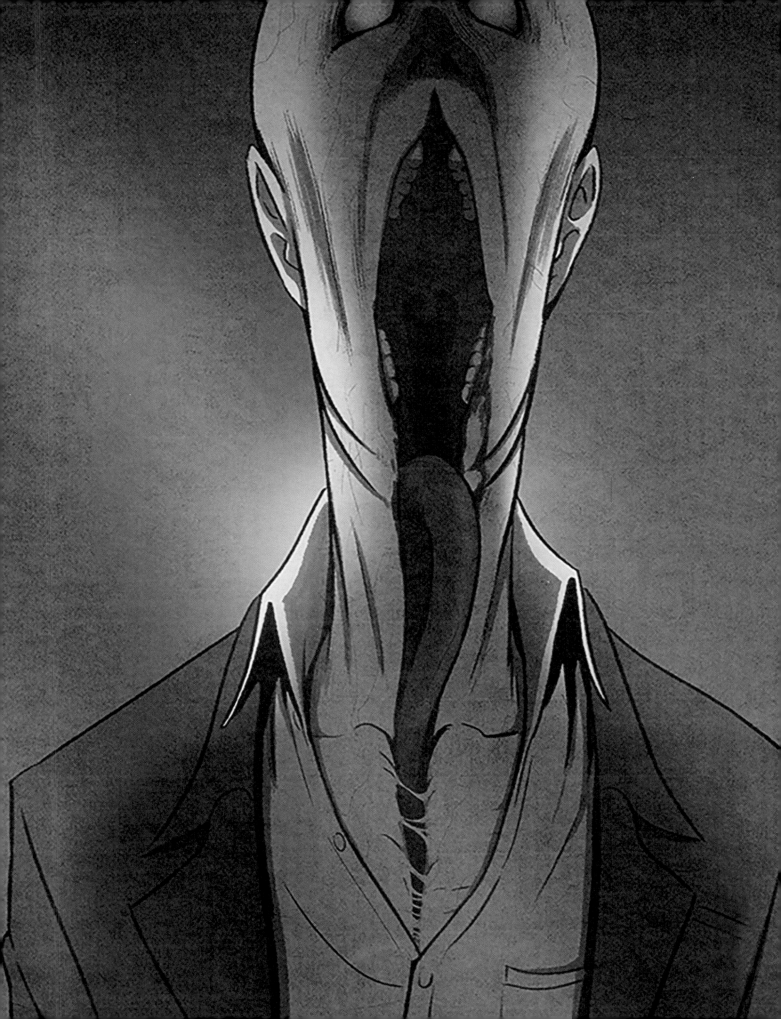

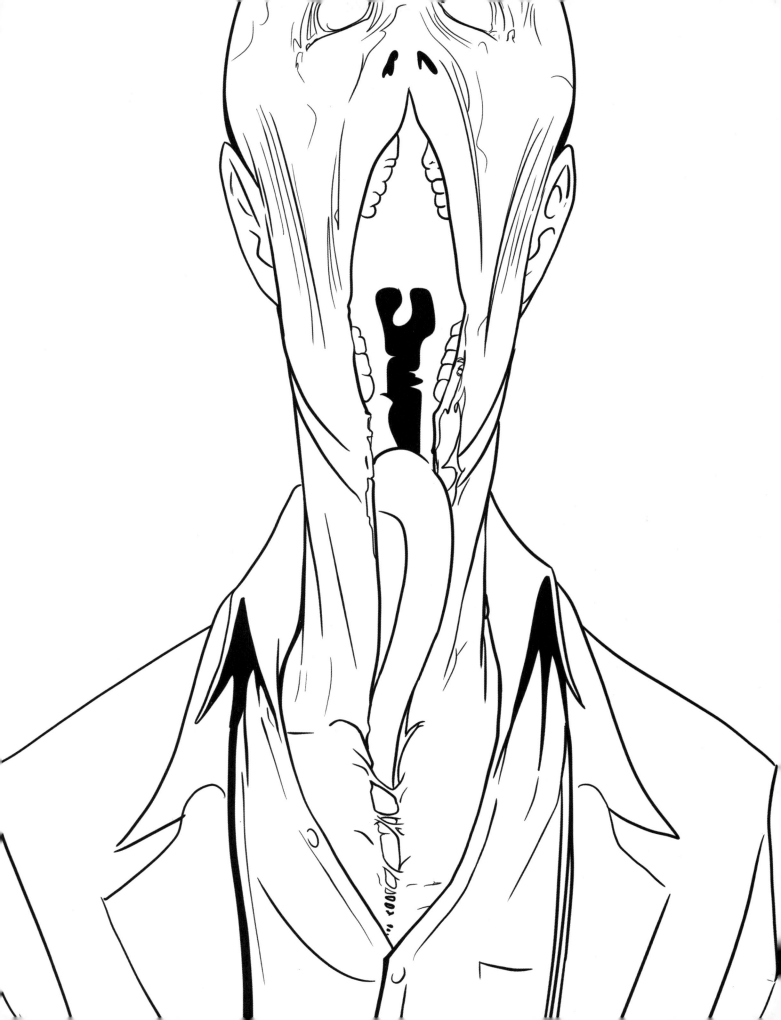

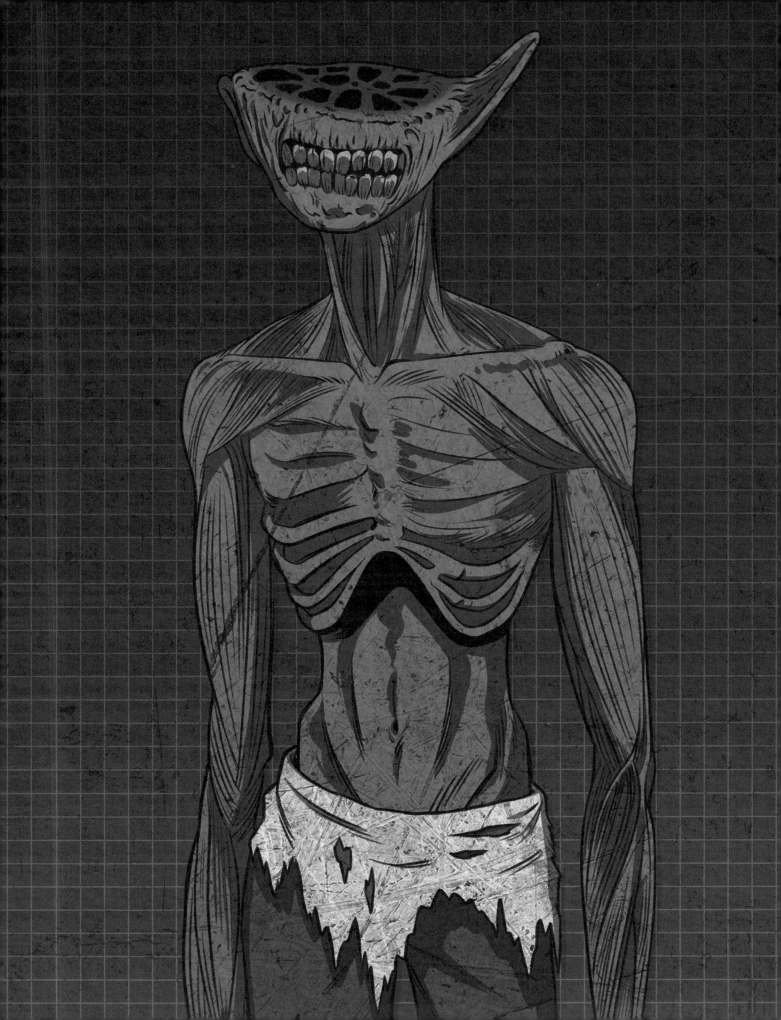

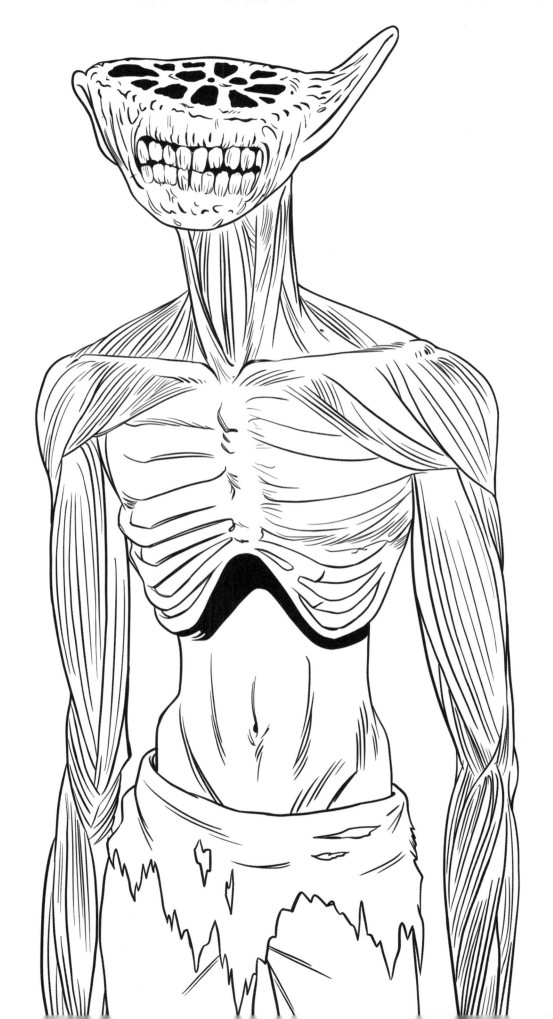

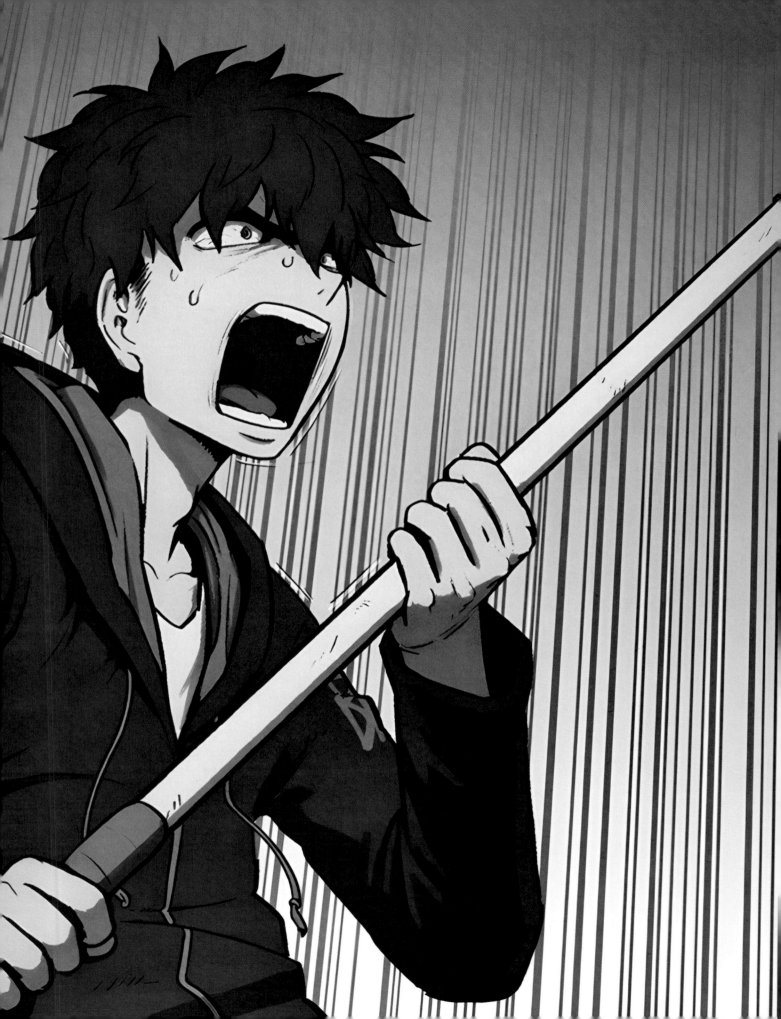

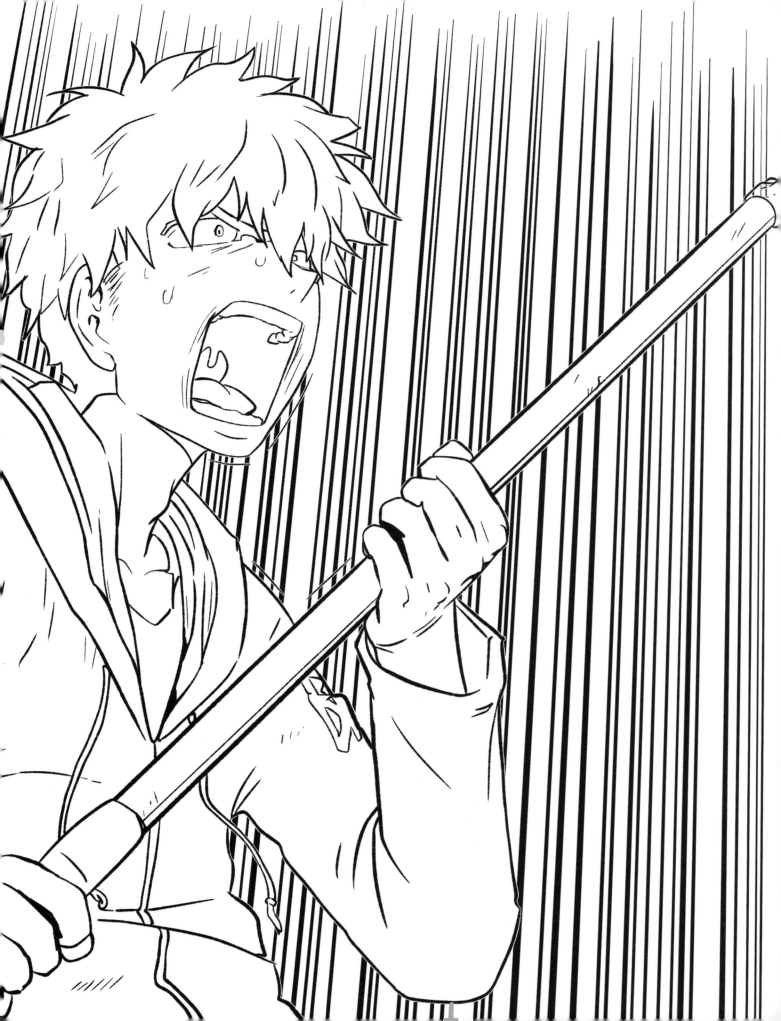

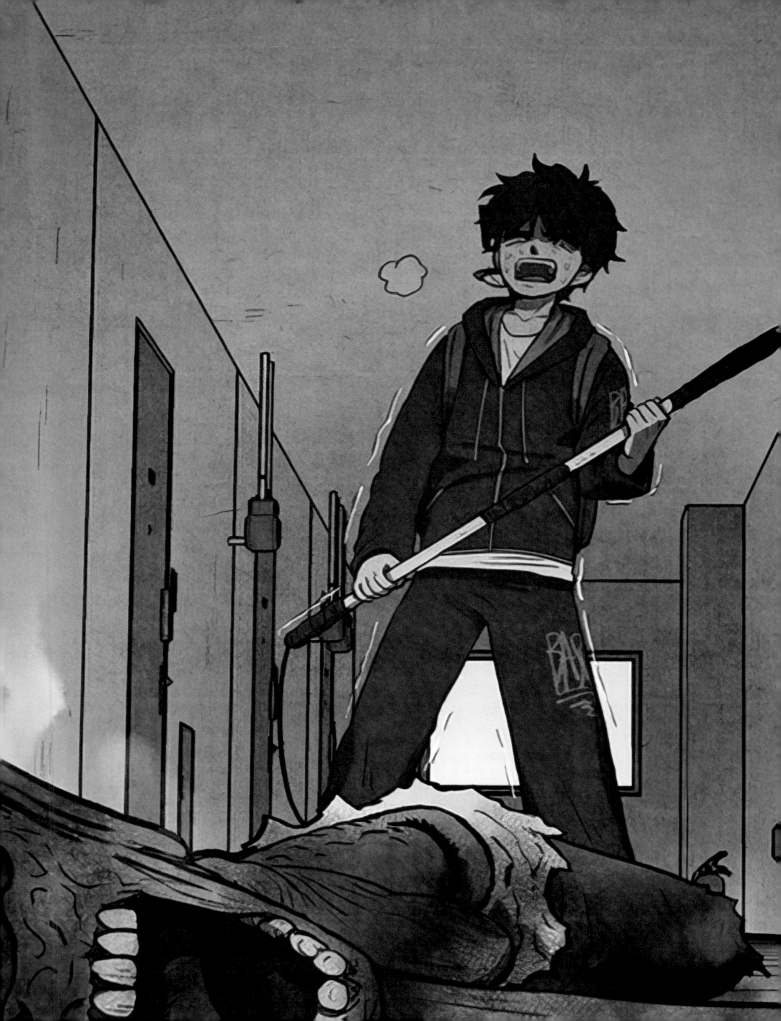

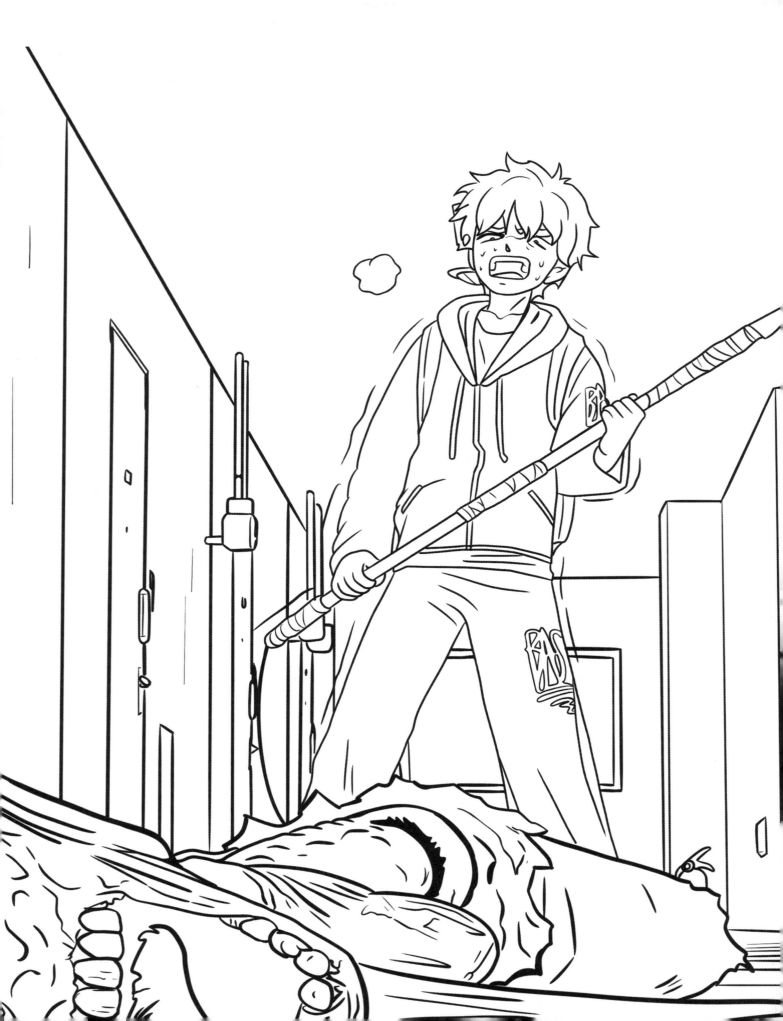

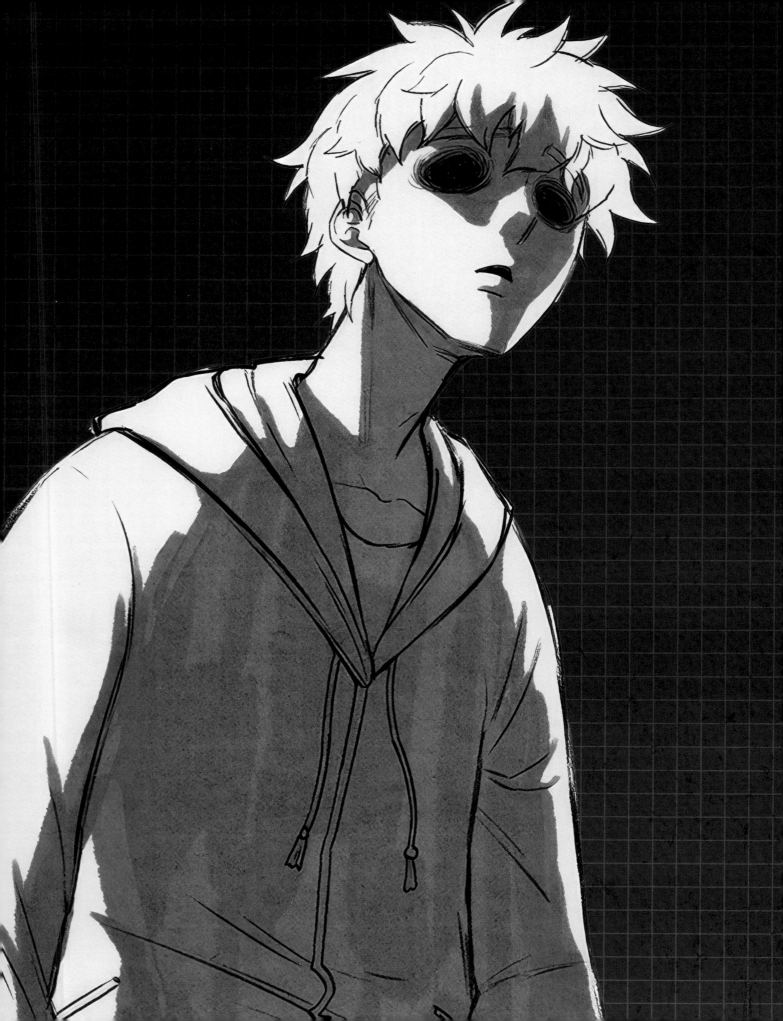

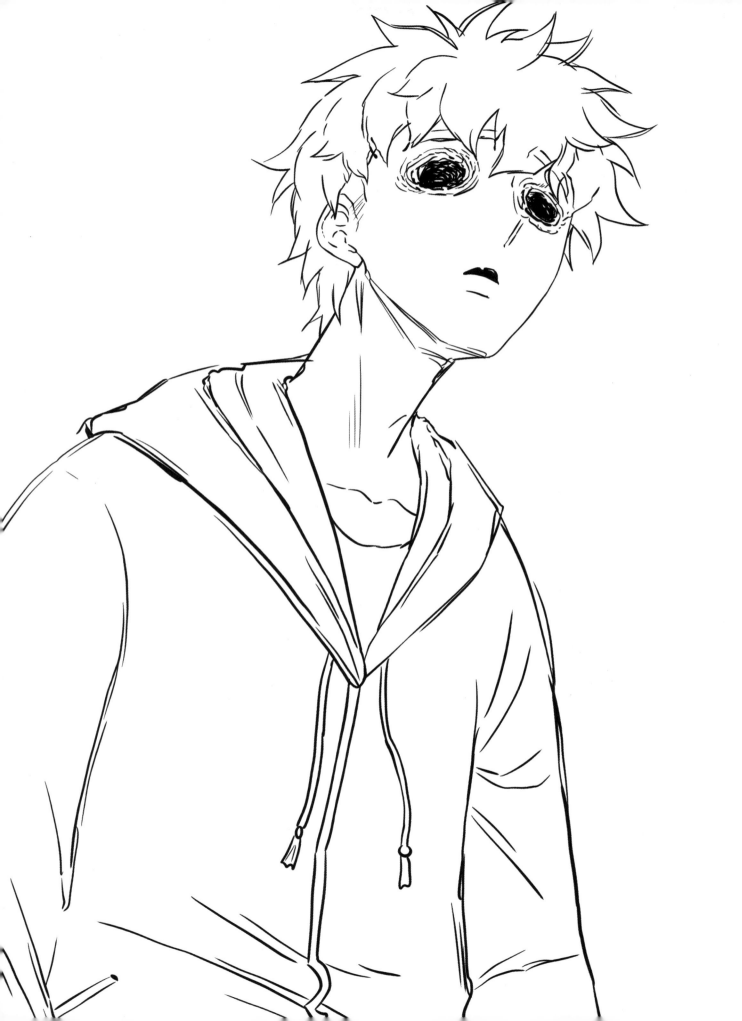

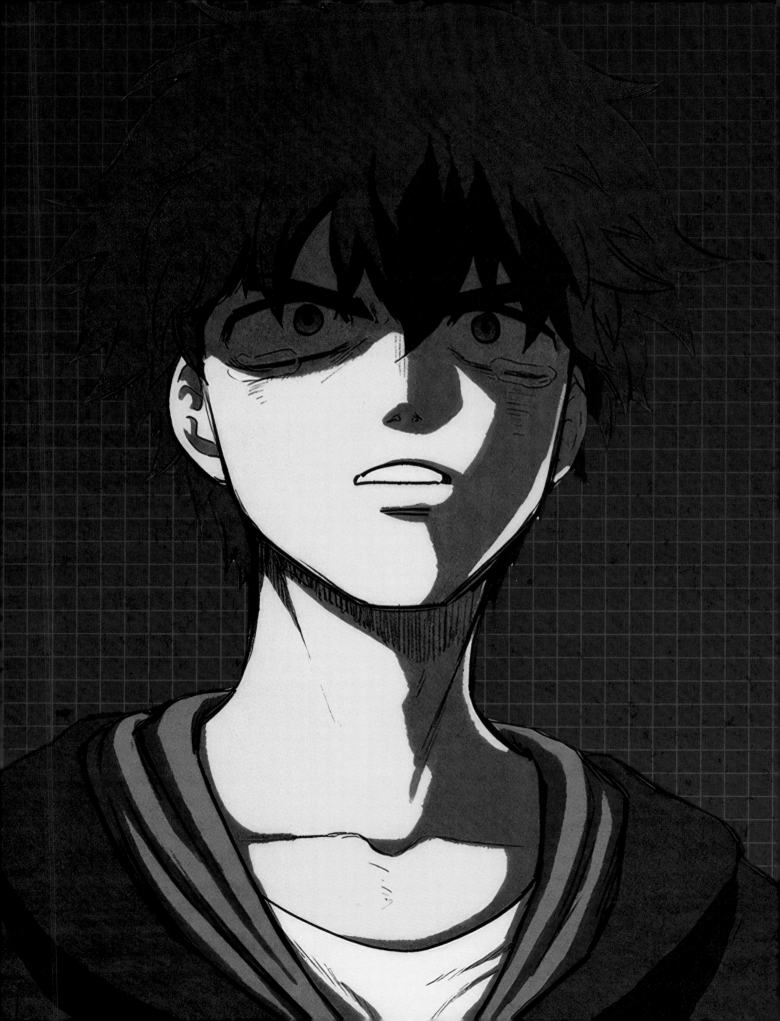

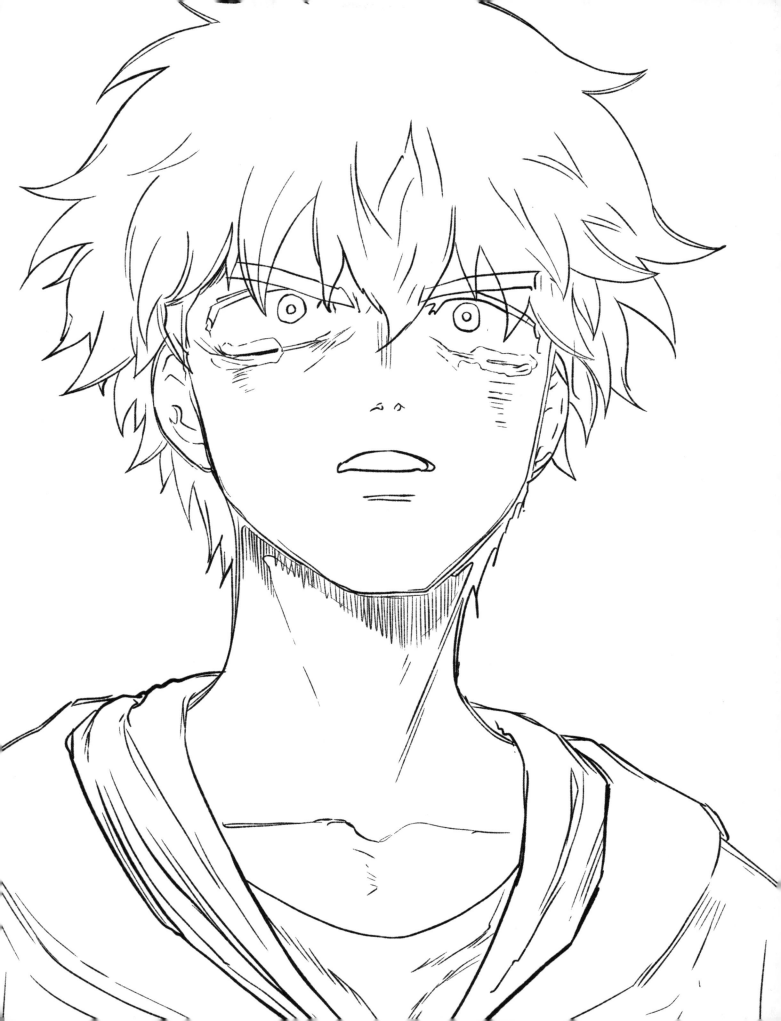

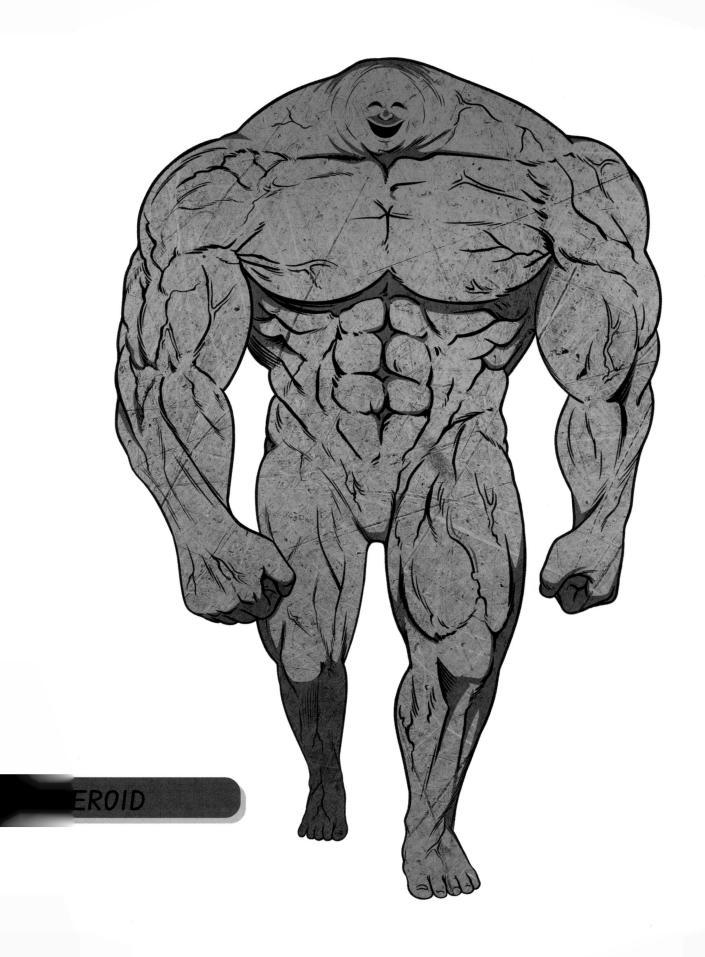

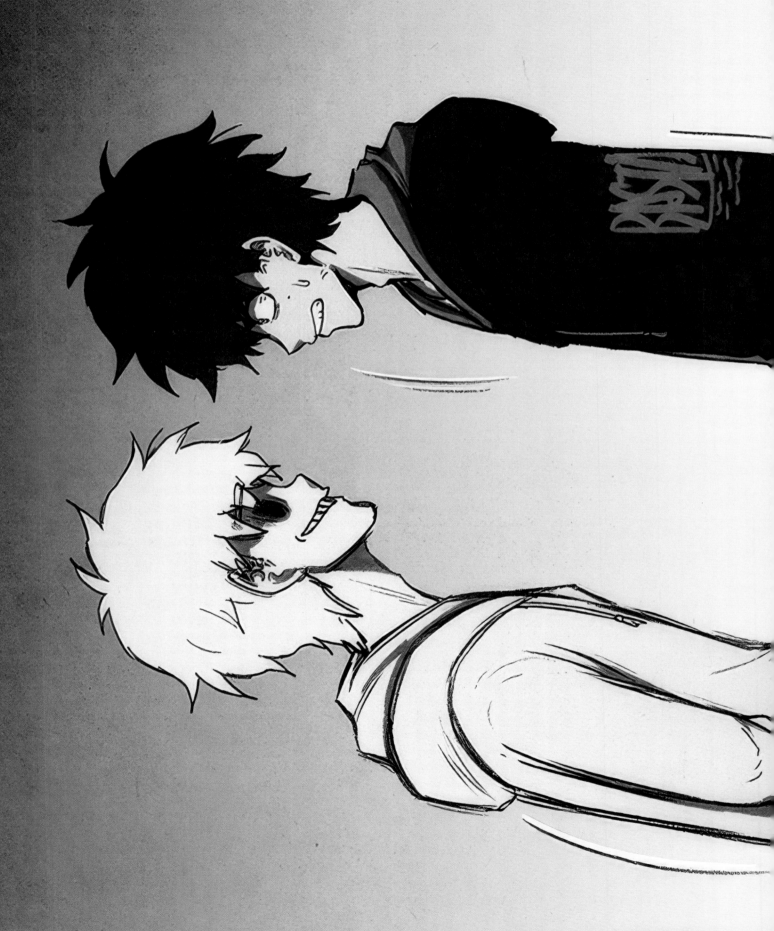

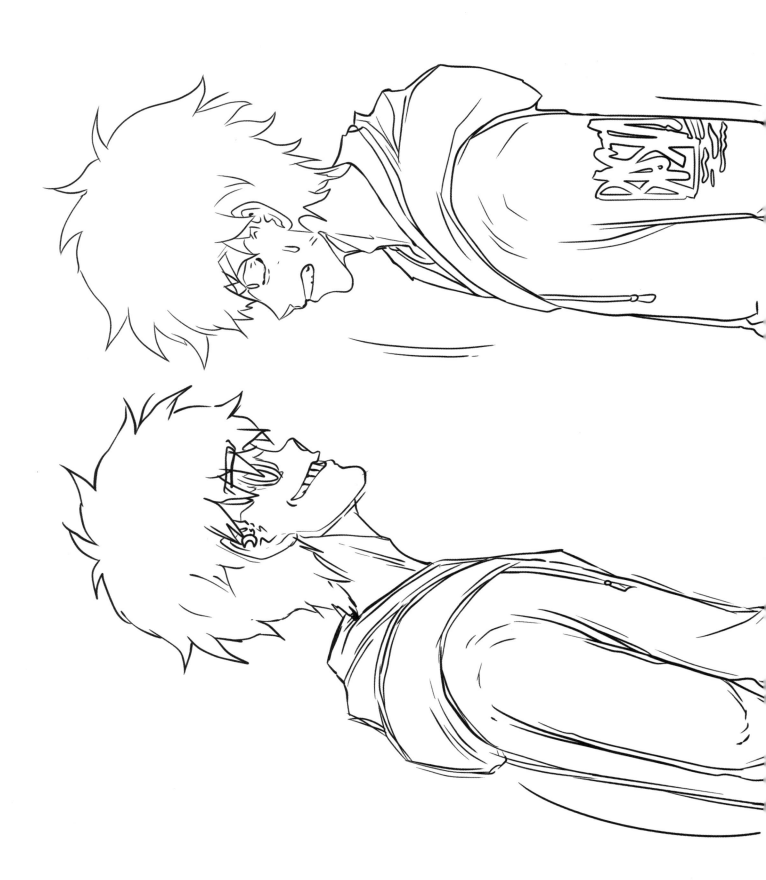

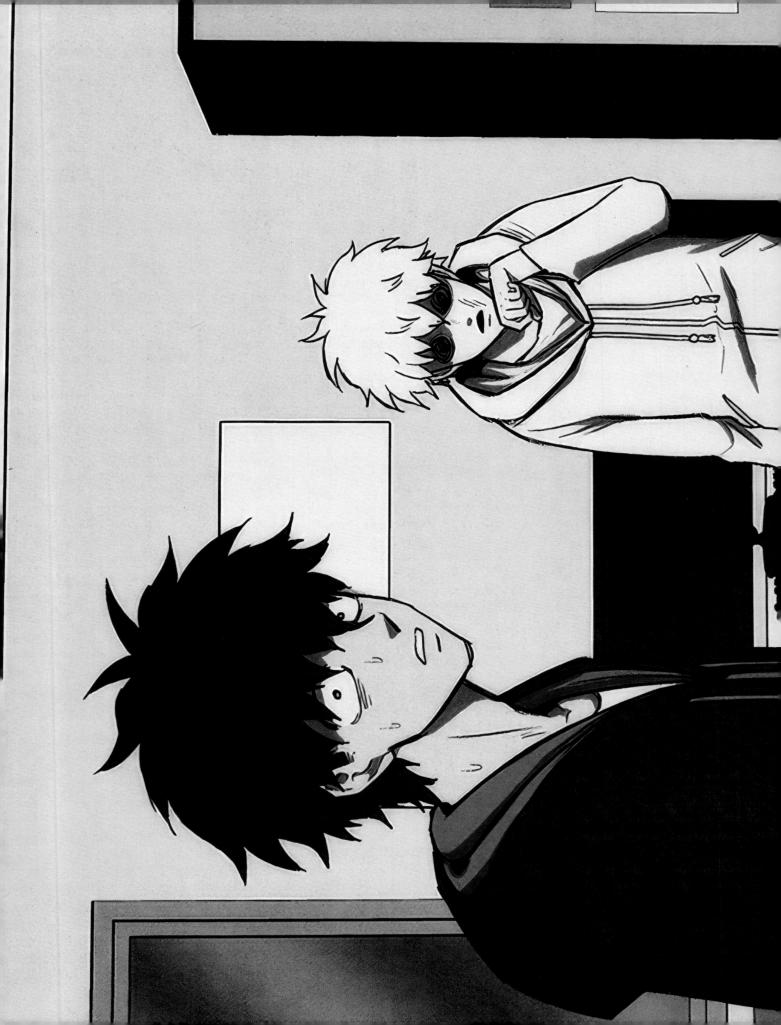

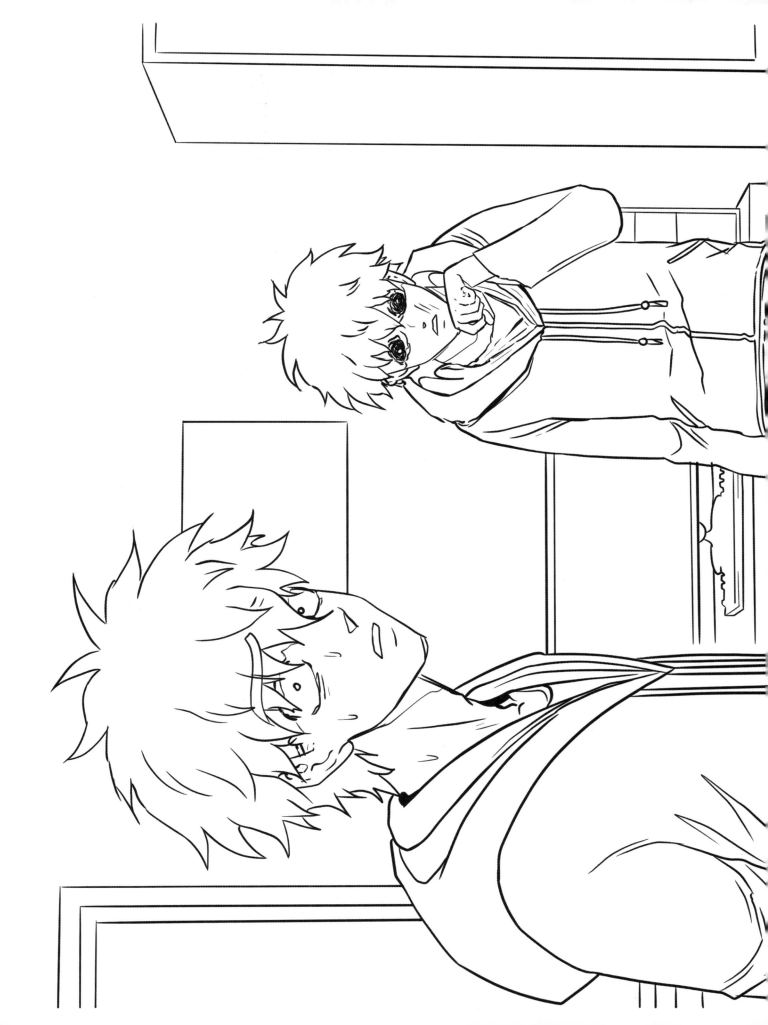

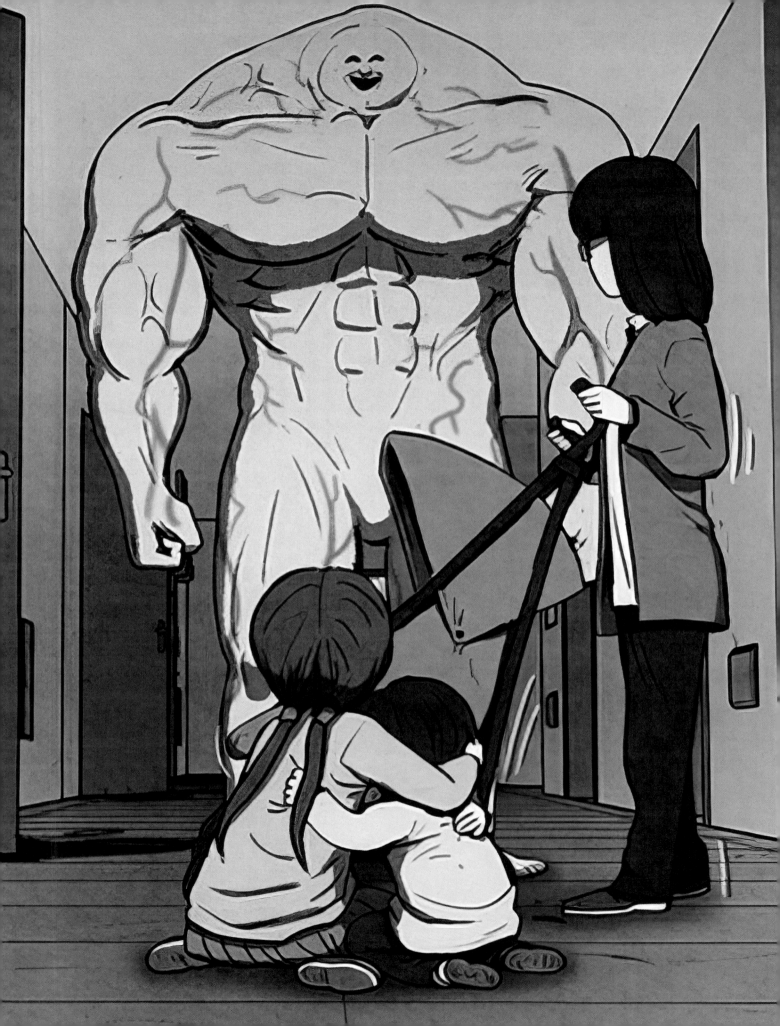

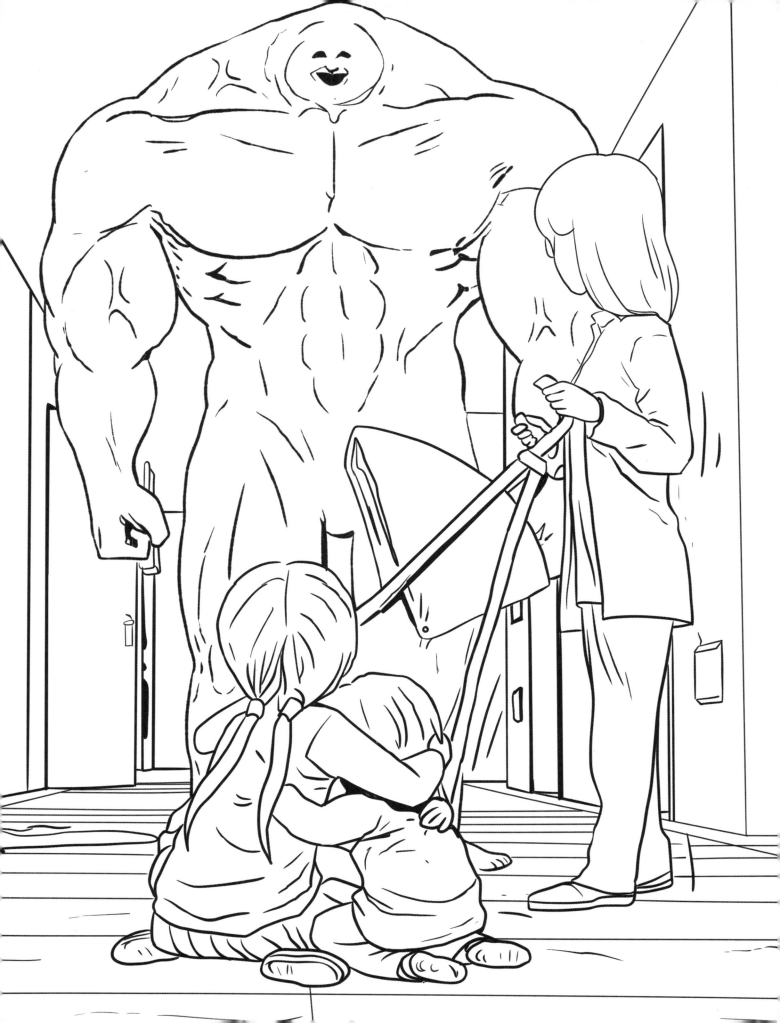

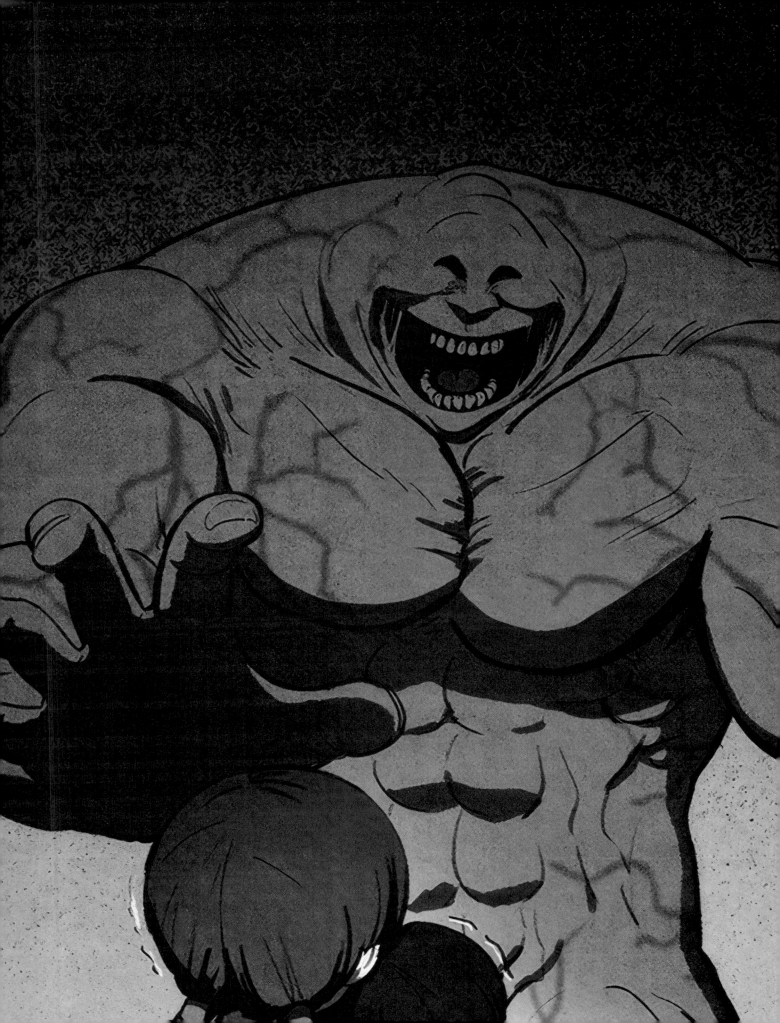

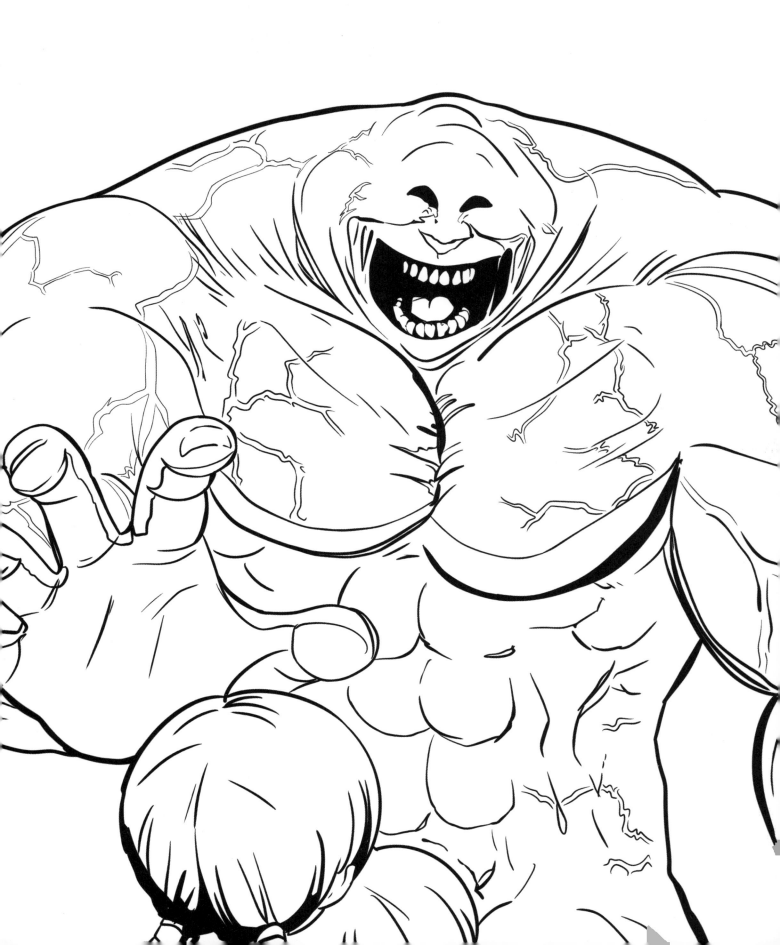

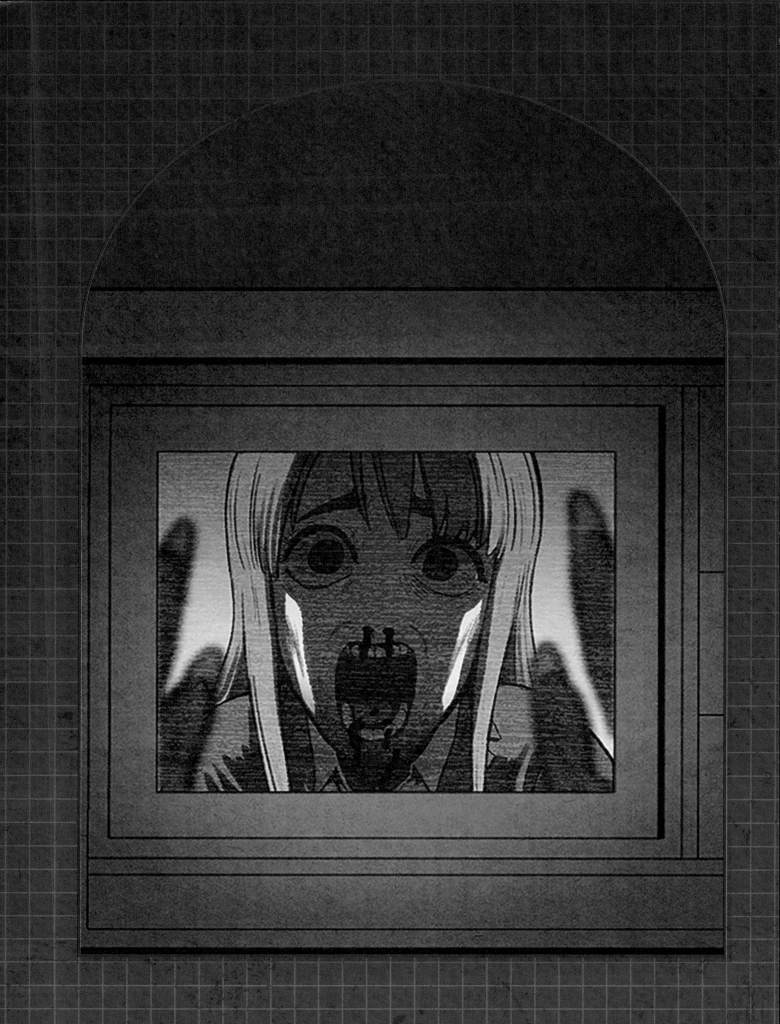

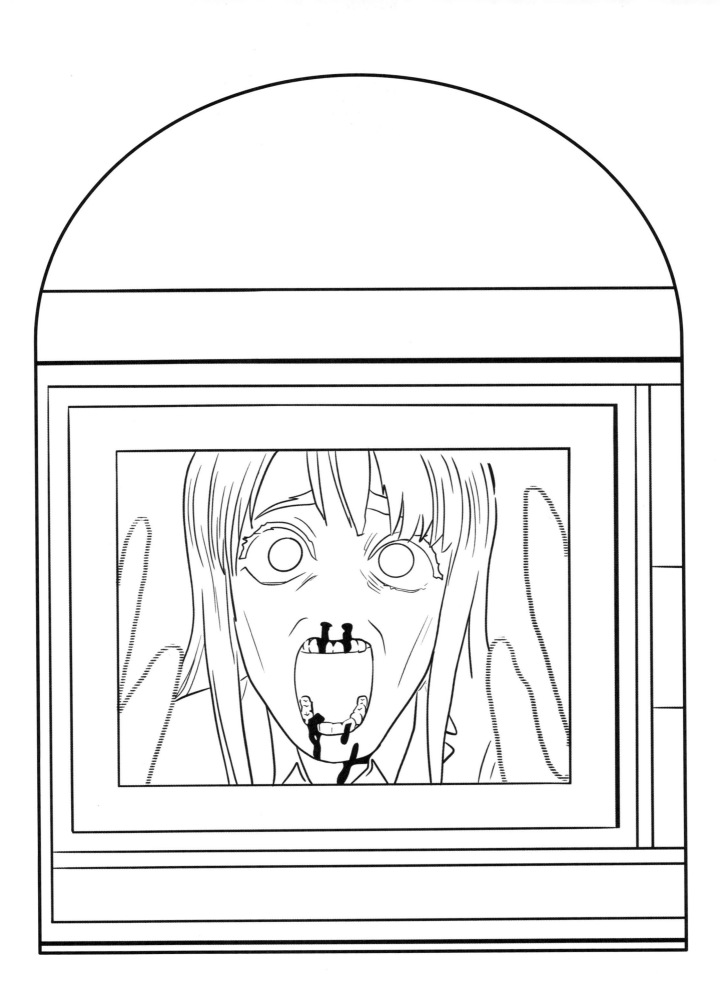

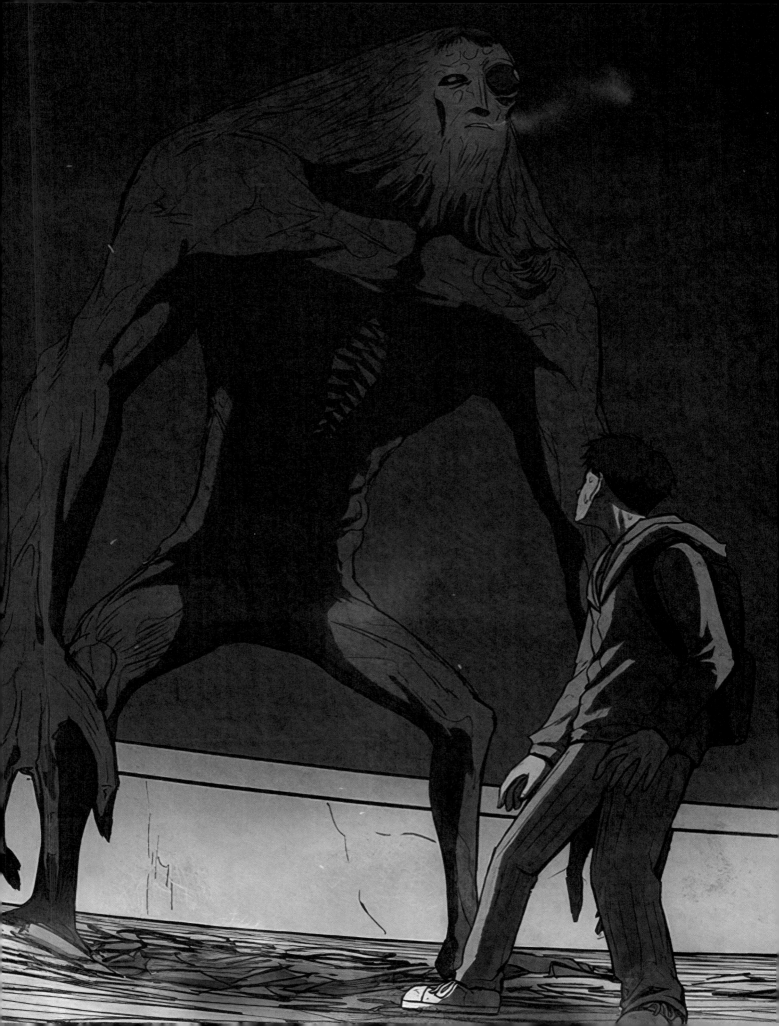

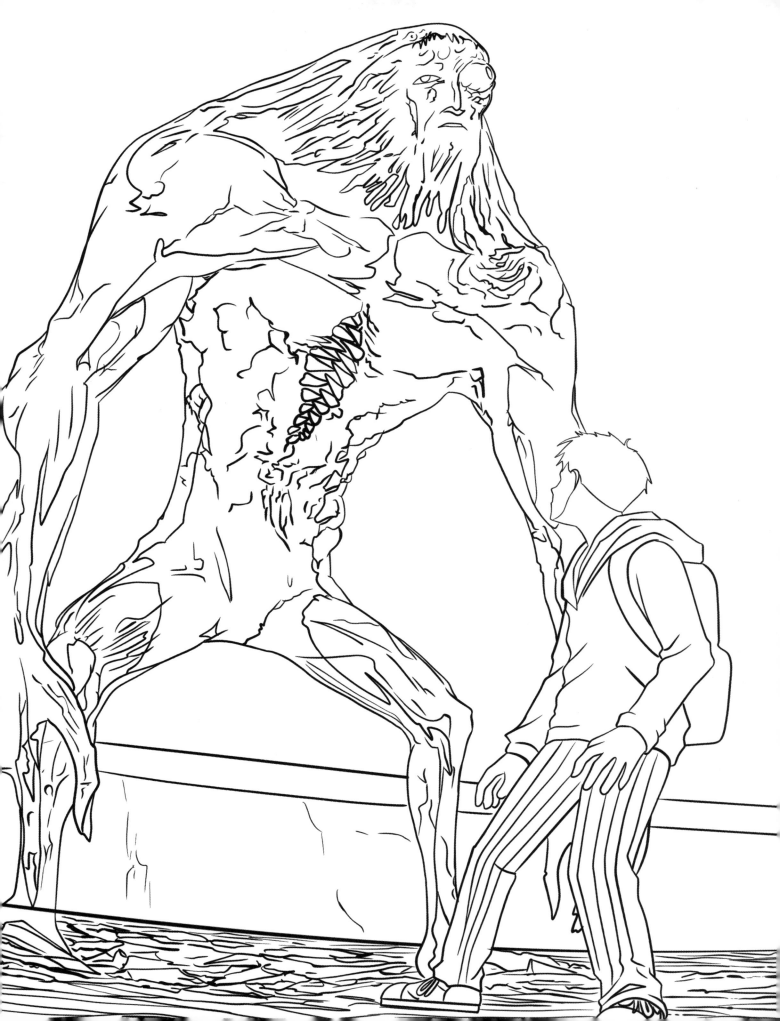

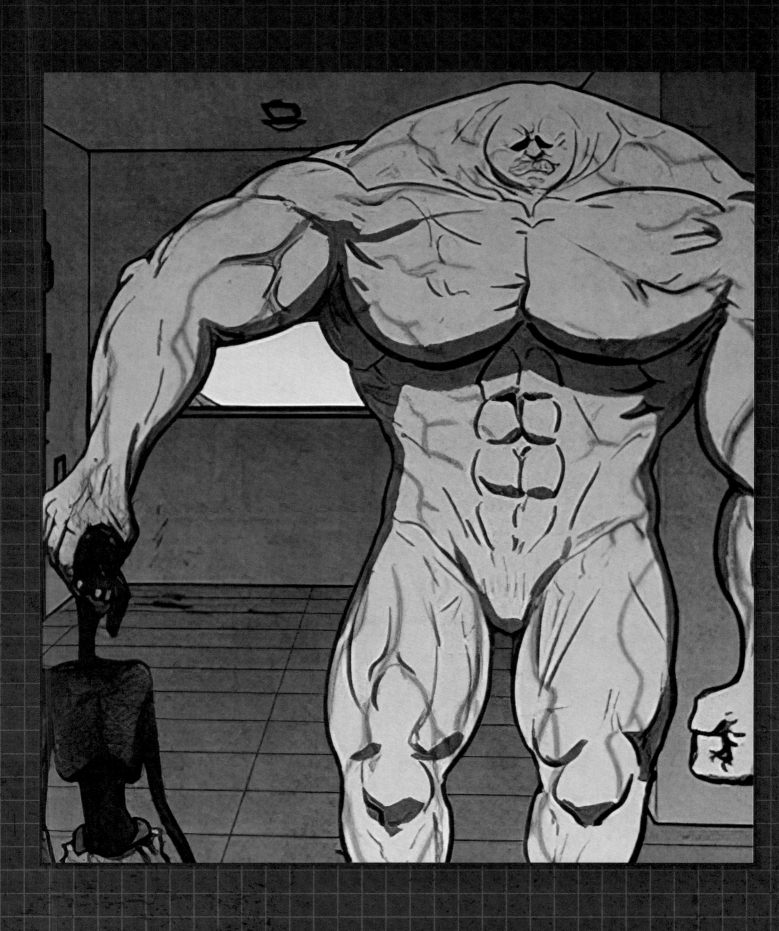

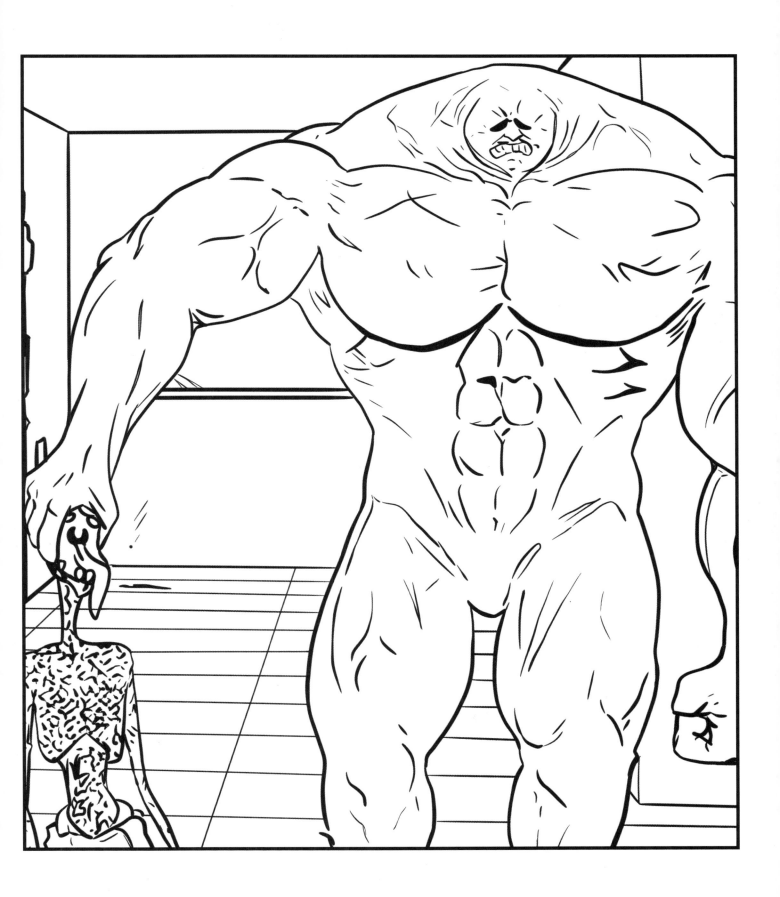

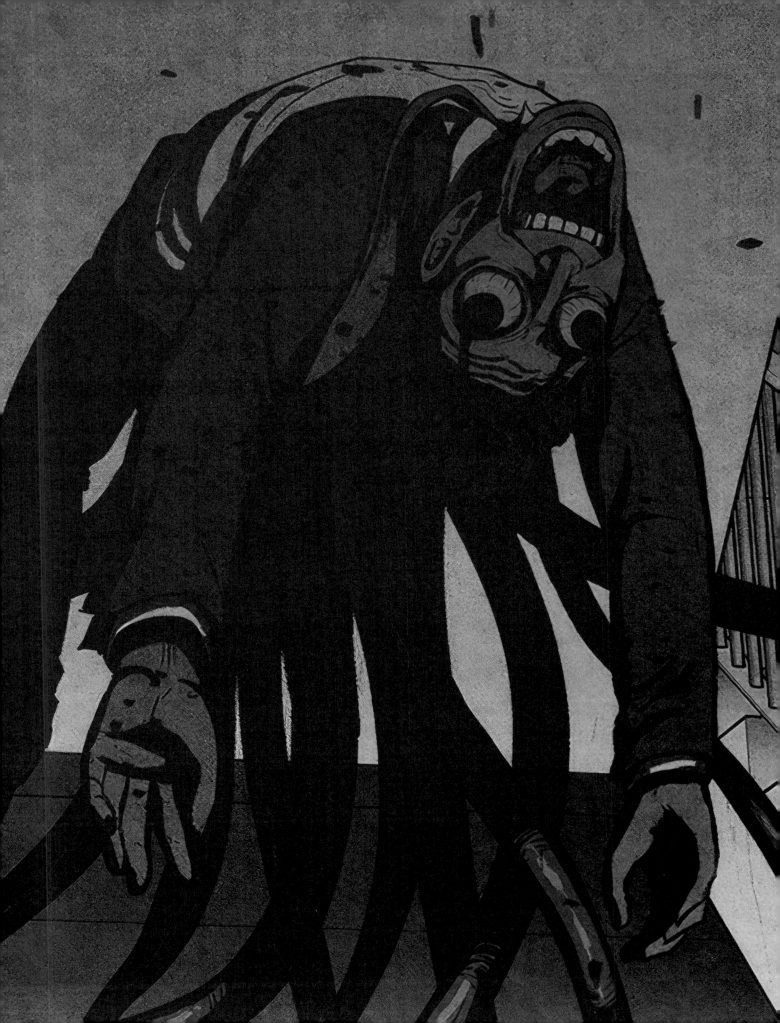

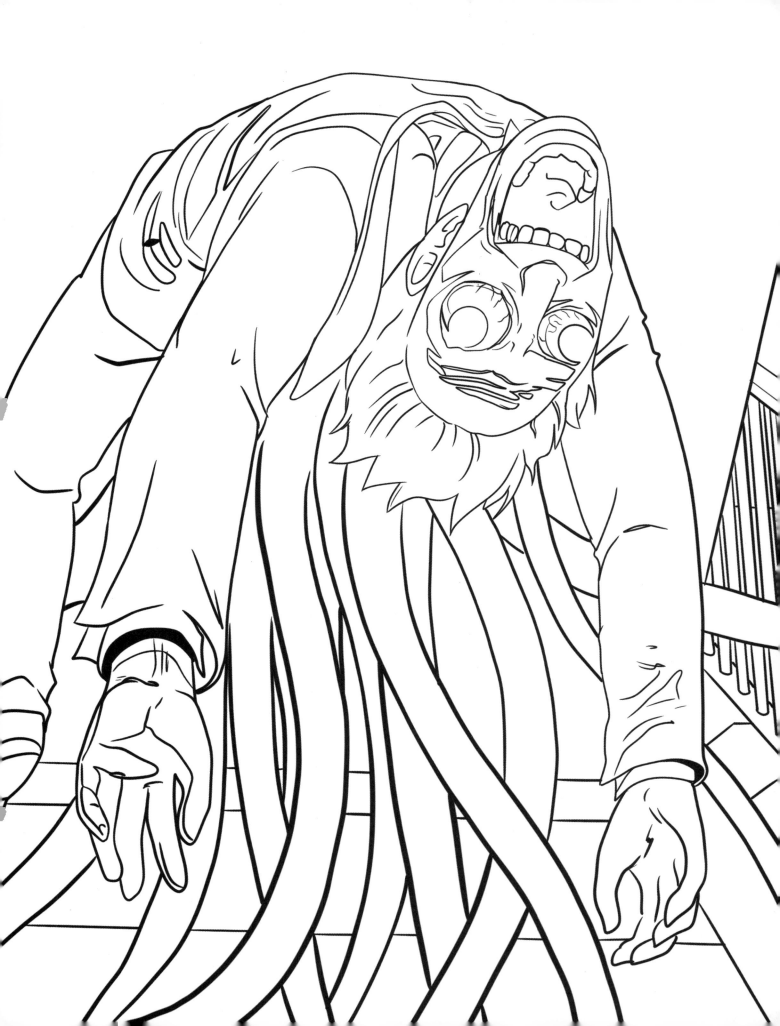

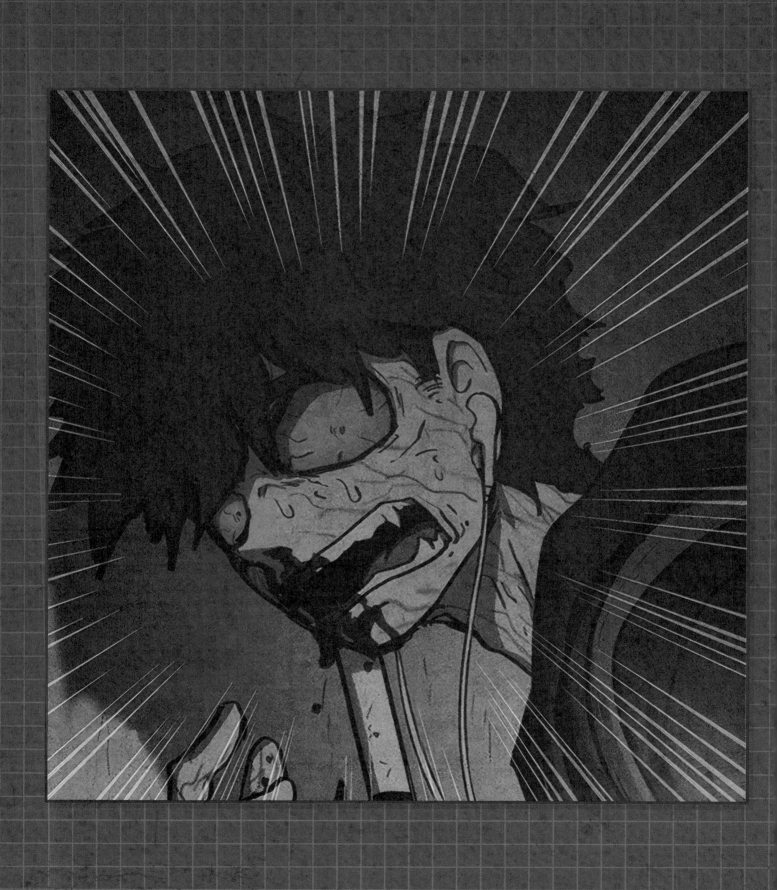

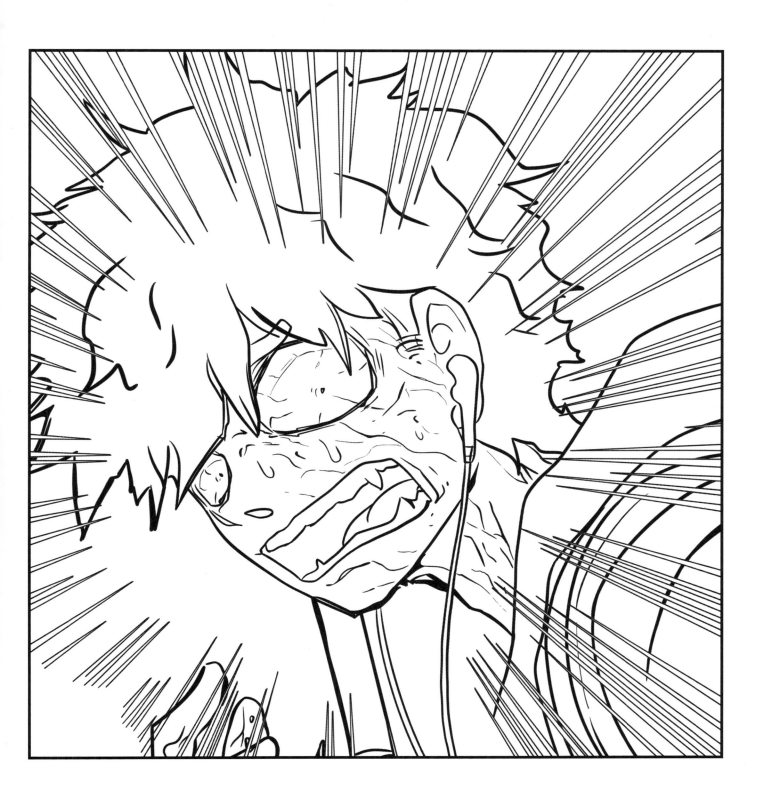

Quarto.com | WalterFoster.com

First Published in 2024 by Walter Foster Publishing, an imprint of The Quarto Group,
100 Cummings Center, Suite 265-D, Beverly, MA 01915, USA.
T (978) 282-9590 F (978) 283-2742

Walter Foster Publishing titles are also available at discount for retail, wholesale, promotional, and bulk purchase. For details, contact the Special Sales Manager by email at specialsales@quarto.com or by mail at The Quarto Group, Attn: Special Sales Manager, 100 Cummings Center, Suite 265-D, Beverly, MA 01915, USA.

10 9 8 7 6 5 4 3 2 1

ISBN: 978-0-7603-8980-5

Line art: Ryan Axxel
Design, layout, and editorial: Christopher Bohn and Coffee Cup Creative LLC
WEBTOON Rights and Licensing Manager: Amanda Chen

Printed in China

ABOUT THE CREATORS

Born in Seoul, South Korea, **Carnby Kim** is best known for being the author of the manga series Sweet Home, Shotgun Boy, Pigpen, and Bastard, and the author/artist of City of Dead Sorcerers series. **Youngchan Hwang** is a Korean webcomic artist and illustrator who collaborates on projects with Carnby Kim.

For more from Carnby Kim, check out:
Instagram @carnbykim